IMAGES
of America

WALL
TOWNSHIP

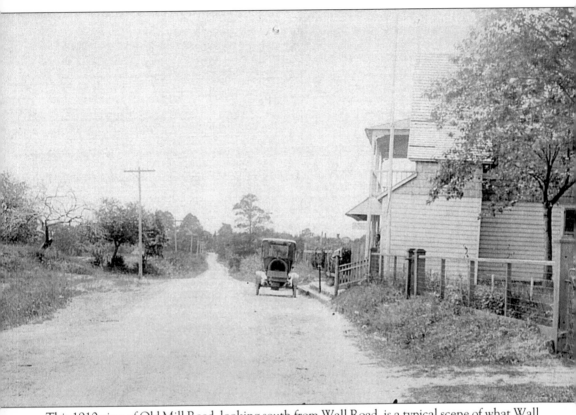

This 1910 view of Old Mill Road, looking south from Wall Road, is a typical scene of what Wall Township looked like in the early years. The building on the right is Tilton's General Store. This section was Wall Township until 1927 and was called Wall Church.

Old Mill Road was one of the main roads at that time running from Sea Girt Avenue in the Blansingburg section to the area of Shark River. Route 35 was built around 1935.

IMAGES
of America

WALL
TOWNSHIP

Richard Napoliton

ARCADIA

Published by Arcadia Publishing,
an imprint of Tempus Publishing, Inc.
2 Cumberland Street
Charleston, SC 29401

Printed in Great Britain.

Library of Congress Catalog Card Number: 99-62317

For all general information contact Arcadia Publishing at:
Telephone 843-853-2070
Fax 843-853-0044
E-Mail arcadia@charleston.net

For customer service and orders:
Toll-Free 1-888-313-BOOK

Visit us on the internet at http://www.arcadiaimages.com

On the Cover: This is a detail of a photograph of the Blansingburg School (see p. 46 for more information).

CONTENTS

Acknowledgments 6

Introduction 7

1. Early Businesses 9

2. Churches and Schools 45

3. Homes and Farms 59

4. Post Offices, Banks, and Railroad Stations 83

5. Police, Fires, and Street Views 99

6. Allaire, Entertainment, and Miscellaneous 111

ACKNOWLEDGMENTS

Local history is fun, especially when one can find old pictures that no one else remembers. To share these findings with interested people is rewarding.

My wife, Grace, and I have traveled across the United States during the past years, and we have collected local memorabilia and postcards. It is quite hard to find anything on Wall Township. I feel very lucky to have such a rare collection, most of which I will share in *Wall Township*.

There are two clamdiggers (someone who has lived in this area all their life) who share my hobby with me: Ted Hill and Bob White. We have been going out to breakfast once a week since we all retired in 1991; we always share our weekly finds and make sure a copy is made for all. Even the storytelling about Wall's early years is interesting. I can't thank these two friends enough for the contributions they have made for this book. Bob White is a past historian of Wall Township and knows the answers to many questions, without having to look them up. He has an amazing amount of knowledge of this town.

I would also like to thank authors Karen L. Schnitzspahn and Patricia Florio Colrick for their encouragement to start this project, and Evelyn Stryker Lewis, author and curator of the Neptune Historical Museum, for the help she gave me getting started on this book. I thank the Old Wall Historical Society for the loan of Dick Hurley. Dick was so much help; he really knows the township's history, especially information on the early families. Many thanks go to the following publications for the contributions from them: James Brown's *Allaire's Lost Empire* (1958); Franklin Ellis' *History of Monmouth County* (1885); Julie Gubitosa's *Wall Township Historic Site Inventory* (1993); *History of the Wall Township Police Department* (1986); the Old Wall Historical Society's *A Pictorial Guide of Old Wall* (1976); the Old Wall Historical Society's *Wall Township: A Quieter Time* (1990); and Lester Woolley's *History of Wall Township Post Offices* (1965).

INTRODUCTION

An act was approved on March 7, 1851, for a new township to be set off from the Township of Howell. This township was called the Township of Wall, in honor of Garret D. Wall.

Mr. Wall was born in Middletown, New Jersey, in 1783. He was licensed as an attorney in 1804 and as a counselor in 1897. He held the positions of clerk of the Supreme Court, was a member of the General Assembly, and was elected a senator in 1834. He was, perhaps, the most popular man of his day in the state. At the time of his death in 1850, he was a judge of the Court of Errors and Appeals of New Jersey.

When the Township of Wall was established, the third amendment from the State Assembly and the Senate of the State of New Jersey, in regard to the Township of Wall being set off from Howell, stated that "the inhabitants of the said Township of Wall shall hold their first town meeting at the Inn kept by Issaac Amerman in said Township of Wall (the New Bedford Hotel) on the day appointed by law for holding the annual town meeting." The fourth amendment stated that "the township committees of Howell and Wall shall meet on the second Tuesday of April next, at ten o'clock in the forenoon, at Shafto's Inn in the village of Lower Squankum, in the Township of Howell, and shall then and there proceed to settle any property settlements of those properties which may be divided by setting off this new township."

The boundaries of Wall at that time were the Manasquan River on the south, Shark River on the north, the Atlantic Ocean on the east, and Howell Township on the west. The towns in Wall Township consisted of Brielle, Manasquan, Sea Girt, Spring Lake, Spring Lake Heights, Belmar, and South Belmar. Some of the older names of these towns were Crabtown and Squan Village (which became Manasquan in 1887), Ocean Beach (which became Belmar in 1893), and Keith, Sea Plain, Reid's Villa, Rogers Park, and Villa Park (all of which became Spring Lake Heights in 1927). Spring Lake incorporated in 1892, Sea Girt in 1917, Brielle in 1919, and South Belmar in 1924.

Other sections of Wall Township included Collingwood Park, Dupont, Blansingburg, New Bedford, Wall Church, Bailey's Corner, Tilton's Corner, and Hurleys' Corners. What is now Glendola was once called Chapel, and Hopeville and Allenwood were, at one time, called Honeytown.

A historical site, Allaire Village, was the location of an iron ore bog in the 1700s. James Allaire began a village there in the early 1800s. It became a Boy Scout camp in 1929, and in 1941 the U.S. Army took it over and held maneuvers on the grounds. Today it is Allaire State Park; it has been fully restored, and is a great place to visit and ride the old train.

Another historical spot is the Camp Evans area, which was originally a farm. In 1913, Guglielmo Marconi operated the Marconi Wireless Company in the area. In 1924, the KKK was headquartered there. In 1938, it was Kings College, and it remained as such until the U.S. Army took it over in 1941. This year, 1999, Wall Township will receive the property back.

The earliest industries in the township were primarily agricultural, consisting of fishing and vegetable, dairy, and poultry farms. Gravel and sand pits were eventually started to ease road construction. As the township grew a number of famous restaurants opened in the area, including The Allaire Inn (which was originally the New Bedford Hotel and later the Le Deauville Inn), DeLisles, Frenches (which later became The Hong Kong Inn), and the Old Mill Inn, which still operates today.

This book contains a little history, but its main purpose is to give everyone a glimpse at what Wall was like back then through the images in my collection and those donated by the many people who share my interest in the history of this wonderful area.

One
EARLY BUSINESSES

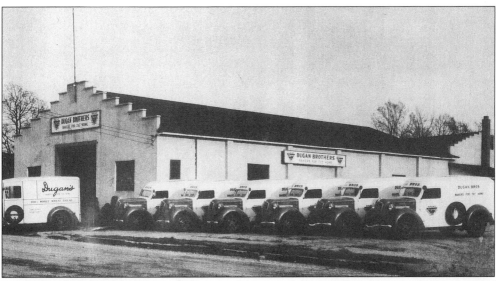

For many years, Dugan Brothers Bakers worked out of the building in the southwest area of Route 34 and Route 33 on the Collingwood Circle. They delivered bread and cakes to homes in the Monmouth County area. In 1968, Dugan went out of business; Bond Bakers took over the building, but they also closed soon thereafter. The home delivery of bread and ice are no longer common; milk deliveries are rare as well. (Courtesy of Bob White.)

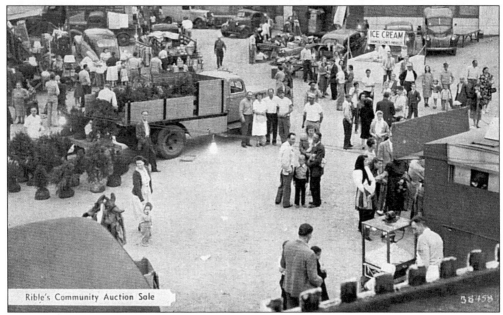

One of the earliest area flea markets was here at Rible's Auction. It was on Route 35 and Eighteenth Avenue just about where the Shop Rite is today. Local farmers would bring in their products, as well as tables full of military surplus and used articles.

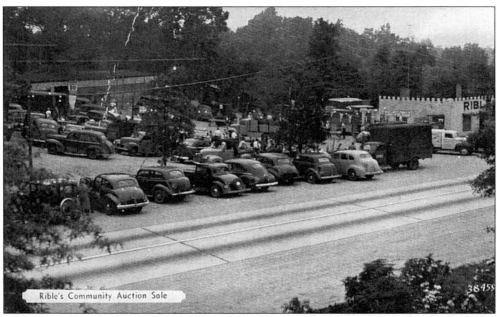

Rible's also had a bar, which was called The Bunny Hop in later years. In the center of the grounds there was a small shack called Rose's, which was believed to be the first and best sub sandwich stand at the shore.

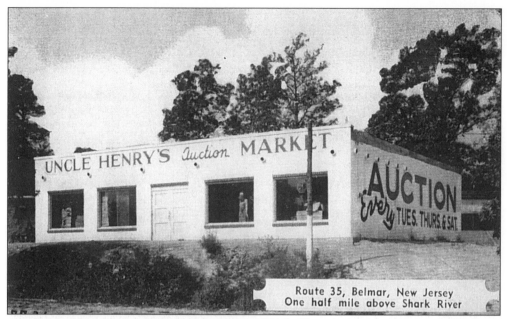

Another building on the grounds of Rible's was Uncle Henry's Auction. They would sell you anything that was ever made.

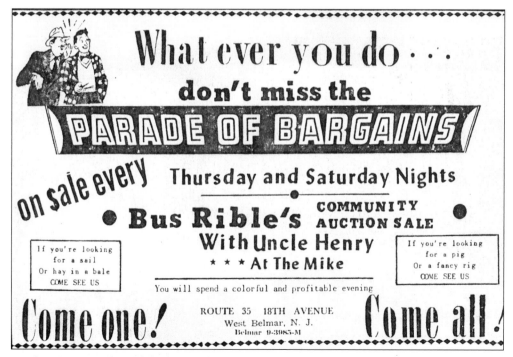

Uncle Henry's Auction did a lot of advertising in the local papers. Rible's started in the 1940s and was demolished around 1960 to make way for progress.

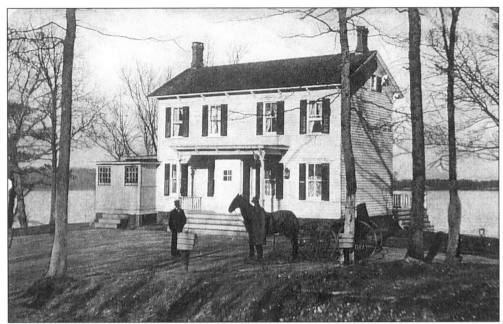

French's Road House was located on North Marconi Road, near Shark River, on the east side in Wall Township. This restaurant was a favorite meetingplace for the local branch of the Ku Klux Klan.

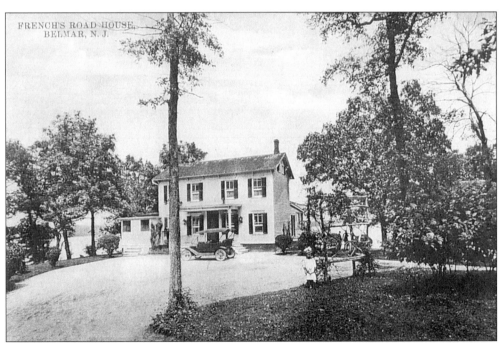

People of Chinese descent purchased this building and called it the Hong Kong Inn. The waiters wore Chinese attire and pigtails. The rooms smelled of burning incense. The owner dressed in a Western-style suit. The building burned down in the 1940s.

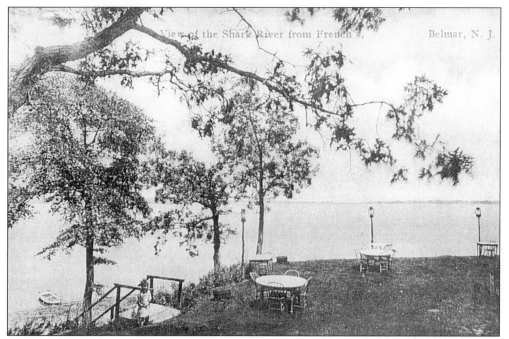

The grounds on the riverside of French's restaurant were used for outside dining. Stairs went to the beach, allowing people to walk or to row a boat after their meal. There are nice homes on the restaurant site today.

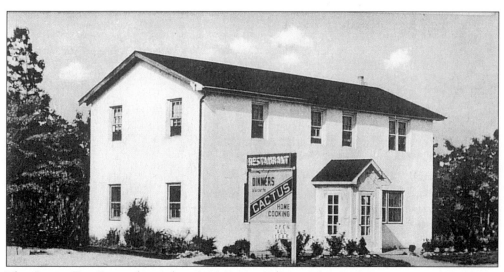

The Cactus Tea Room, located at 5100 Route 33/34 on the northwest corner of Catherine Street in the Collingwood section of Wall Township, featured home cooking specialties. The building houses a home improvement business today.

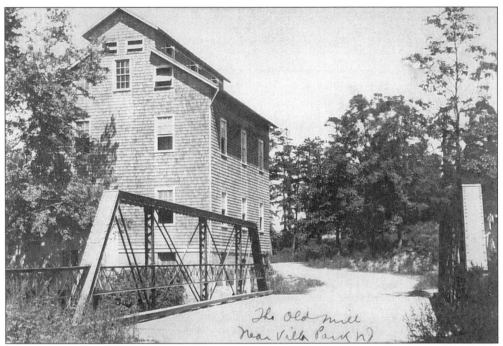

Local farmers brought their grain to this mill, located on Old Mill Road in Spring Lake Heights (so-called since 1927), to be ground. The first mill at this location began operating in 1720.

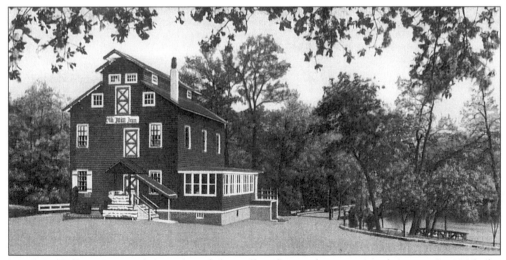

In 1938, William Brauweiler purchased the mill and started a restaurant business. In 1985, the building was destroyed by fire; a new building was later built on the site.

Zebulon Stilwell ran the old mill in 1923. Advertisements on his billhead show some of the different products made there.

This *c.* 1923 billhead was made out to E.A. Bennett. His farm was just south of the Manasquan Circle. It will be featured in another part of this book.

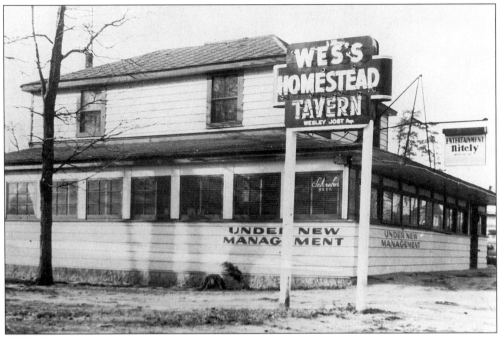

This old watering hole on Route 71 in West Belmar has been at the same location for many years. It started as Two Pals and has had such names as Wes's Homestead, Peacock, Station House, Charlie's Sandbox, and Seven Cuisines. It is currently The Tidal Wave.

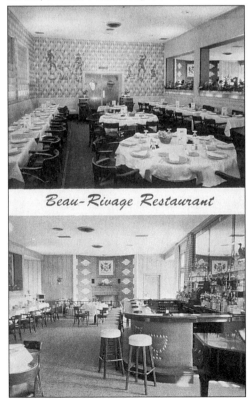

The Beau Rivage restaurant was located on Warren Avenue and Old Mill Road. Built in the 1950s, it was a favorite spot to dine. When it changed hands, it was called Charlie's Five. The building burned down on December 2, 1962.

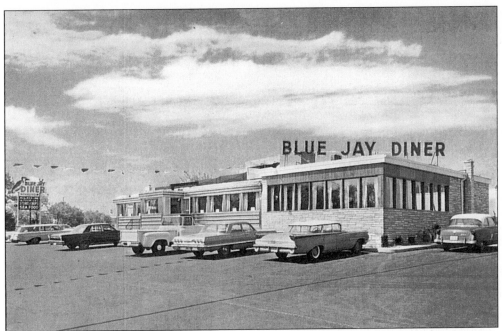

The Blue Jay Diner was moved from Route 35 near Fort Monmouth in the 1960s to Route 35 in Wall. It was on the site where McDonald's and K-Mart are today. The diner was put right in front of an old home on the location and the home was used as a kitchen. The diner later became the Country Squire. It was destroyed by fire in the 1980s.

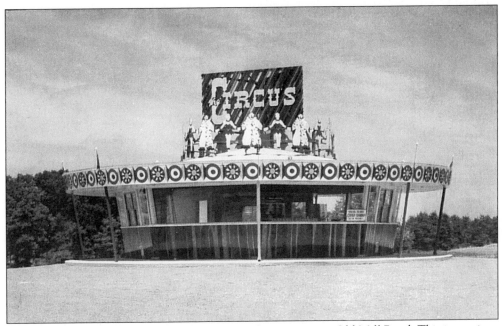

The Circus Drive-In restaurant is on Route 35 almost opposite Old Mill Road. This is a unique restaurant established in the 1950s to serve food to Americans, who were in love with their cars. It offers inside dining and carhop service. The design and operation of the business has not changed since. (Courtesy Wall Township Historic Sites Inventory, 1992.)

The Le Deauville Inn was on Eighteenth Avenue and New Bedford Road where Wall High School is today. The famous restaurant was owned and operated by Francis Dubac and family from 1925 until 1951. They then opened the inn on Gully and Remsen Mill Roads. It was sold and burned in 1981. Note the New Bedford Schoolhouse, which can just be seen in the distance. (Courtesy of the Dubac Family.)

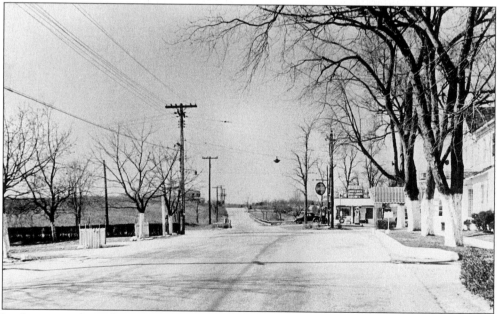

Looking west from the Le Deauville Inn on Eighteenth Avenue, you can see Bixler's Gas Station. Before it became a restaurant, the inn was called the New Bedford Hotel and was a stagecoach stop. Court was also held there for a time. (Courtesy of the Dubac Family.)

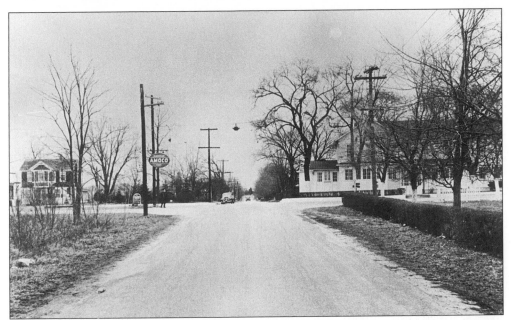

This view looks north from New Bedford Road to the Le Deauville Inn. The police officer on the corner must have been Police Chief Vernon Shibla, as there were no other officers at that time. (Courtesy of the Dubac Family.)

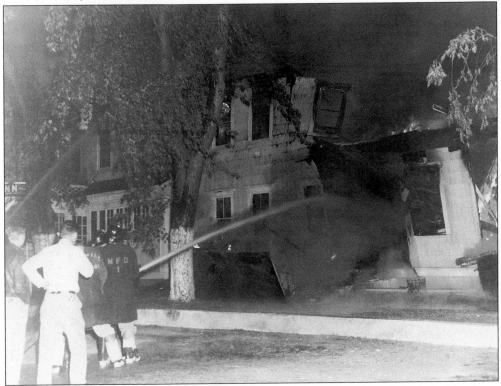

This historic building burned down in October 1951. In the early 1960s, Wall High School was built on the site.

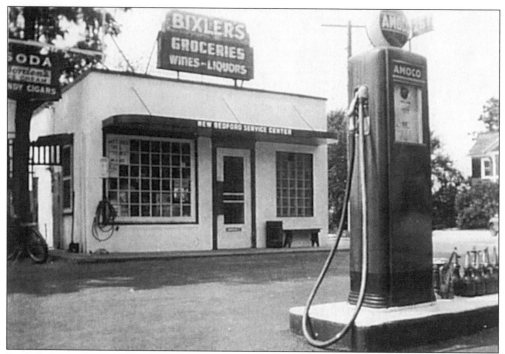

Bixler's Store was on the corner of Eighteenth Avenue and Hurley Pond Road. Mr. Howard Bixler lived in a home behind the store and ran it from the 1940s until the 1960s. Since then, it has become famous for its sub sandwiches.

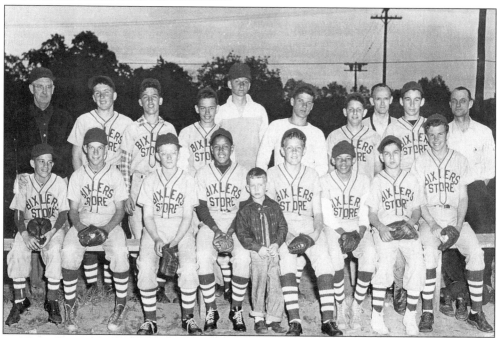

Mr. Bixler came from Reading, Pennsylvania, and played a lot of baseball there. In 1953, he sponsored this baseball team in Wall Township. Mr. Bixler is shown here at the top on the far right. (Courtesy of the Dubac Family.)

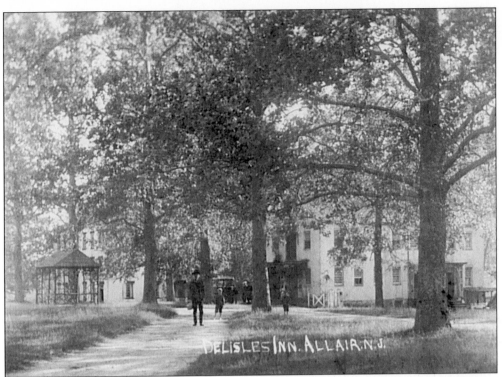

William DeLisle began the restaurant business in Allaire. This postcard view of the restaurant is postmarked 1906.

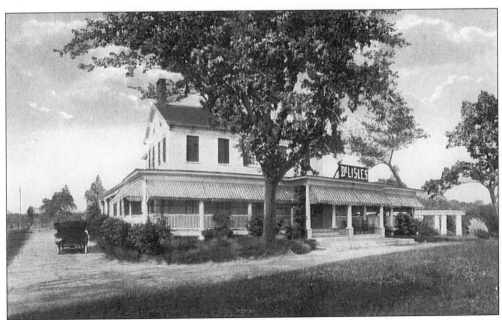

DeLisle's French Restaurant was on the southeast corner of west Eighteenth and Atlantic Avenues. In those days, it was the main road to Philadelphia and Trenton.

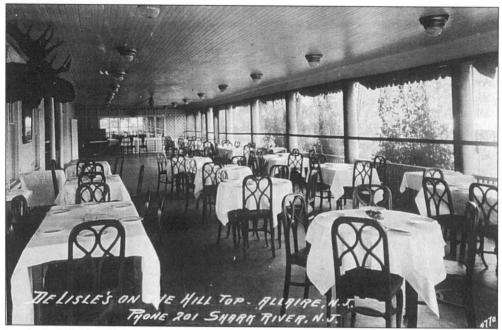

Just look at the view when you dined on the porch at DeLisle's French Restaurant.

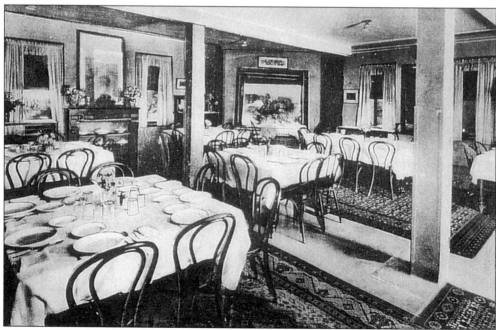

This dining room is filled with the old-fashioned bentwood chairs. The tables seem already set for some affair.

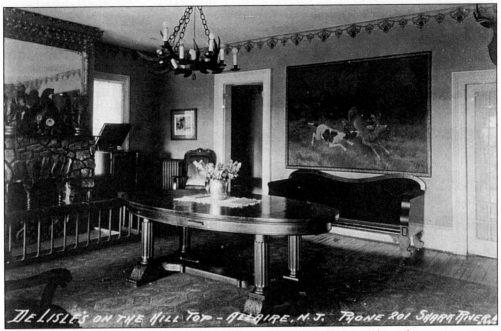

This plush place must have been a waiting room. Note the phonograph in the corner next to the fireplace. A large painting hangs on the wall.

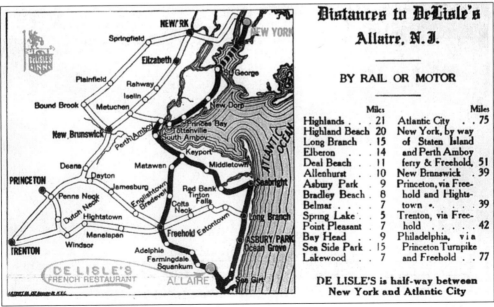

Distances to DeLisle's Allaire, N.J.

BY RAIL OR MOTOR

	Miles		Miles
Highlands	21	Atlantic City	75
Highland Beach	20	New York, by way	
Long Branch	15	of Staten Island	
Elberon	14	and Perth Amboy	
Deal Beach	11	ferry & Freehold,	51
Allenhurst	10	New Brunswick	39
Asbury Park	9	Princeton, via Free-	
Bradley Beach	8	hold and Hights-	
Belmar	7	town	39
Spring Lake	5	Trenton, via Free-	
Point Pleasant	7	hold	42
Bay Head	9	Philadelphia, via	
Sea Side Park	15	Princeton Turnpike	
Lakewood	7	and Freehold	77

DE LISLE'S is half-way between New York and Atlantic City

The map in his brochure made sure that Mr. DeLisle's customers knew where he was. This inn burned down in the 1930s. Its stone posts marked the entrance to the driveway for many years.

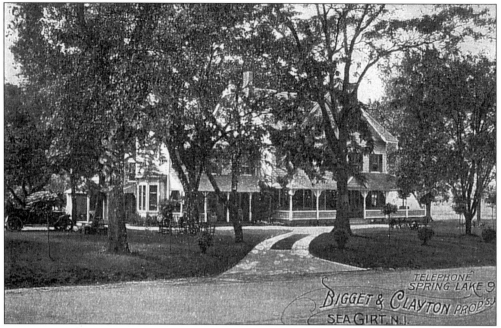

Biggets was a house on the site of the former Sea Girt Inn, which burned down in 1918. The newspaper reported that there was a strong north wind and Floden's Florist almost caught fire, but firemen managed to save it.

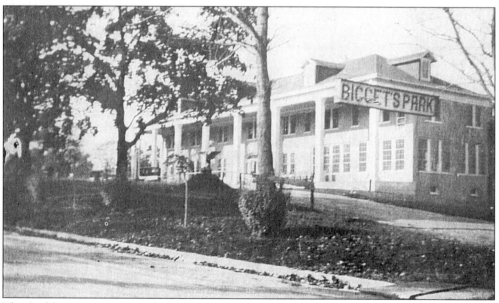

This building was constructed after the fire as a showplace. Later it was called Jimmy Burns and the Sea Girt Inn. It was razed in June 1997.

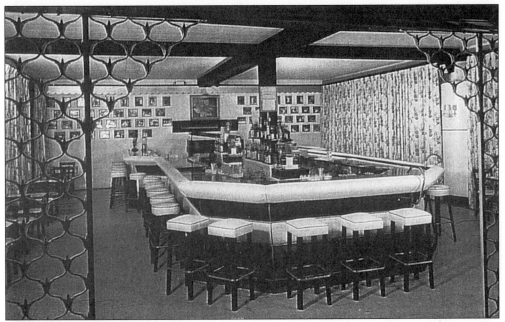

The drapes in the interior view of the Sea Girt inn barroom opened on both sides to make a larger room.

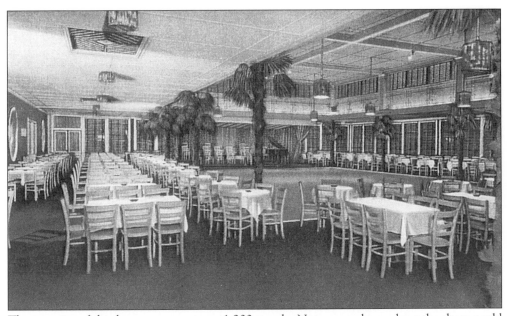

The capacity of this large restaurant was 1,200 people. Not many places along the shore could hold that many customers. This picture is of the dining and ballroom.

The Wall Fishery was located on Ocean Avenue and the Seventeenth Avenue Beach. The office, located at 101 Seventeenth Avenue, is now a summer home. The fish pound poles could be seen offshore; they held the fishnets. The boats were pulled onto the beach by horses.

No. 565 MANASQUAN, N.J. *Nov 5 1906*

FIRST NATIONAL BANK

PAY TO THE ORDER OF *The Great American Tea Co*

Thirteen 30/100 **DOLLARS**

THE WALL FISHERY.

$13 30/100 By *A Woolley*

Treasurer.

THE WALL FISHERY, COMO, N. J.

Augusta (Gus) Woolley (the great-grandfather of the author) was born in the New Bedford section of Wall Township on a farm on Glendola Road owned by his father, William H. Woolley. Gus owned and operated the business from the 1890s until 1933, when he passed away at his home in Spring Lake. His 1906 check is made out to the old name of the A&P Store.

26

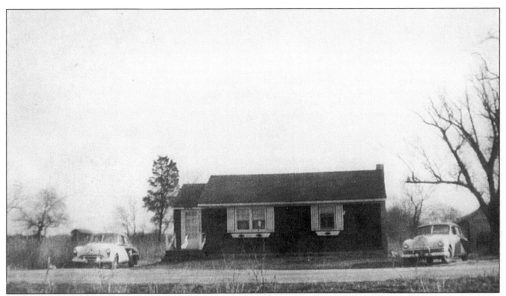

Bill and Eileen Tilton ran a taxi business from their home at 1736 New Bedford Road in the 1950s. Note the two black-and-white cars in the road

TAXI BELMAR 9-1606-M

TILTON'S TAXI SERVICE

Ride the Black and White Cabs

24-HOUR SERVICE

The Tilton home was located on the site of the old William D. Woolley homestead. Della Hill worked for the Tiltons by taking business phone calls. (Courtesy of Ted and Della Hill.)

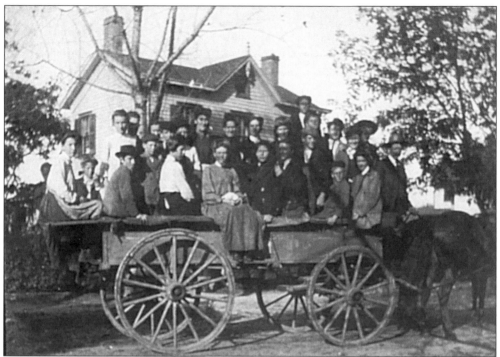

In the early days of Wall Township, cranberries were an important crop cultivated to be sold in the larger cities. Much of the land around the outlining areas of West Belmar were low and swampy; these areas have since been filled in. In the lower area north of Curtis Avenue (near Sixteenth Avenue) and around Polly Pod Brook (southern end of Route 71), many cranberries were reportedly raised. (Courtesy of Bob White.)

Conklin's Trailer Park was located on Route 71 on the southwest corner of Eighteenth Avenue in West Belmar. It closed down in the 1980s.

Dear Neighbor—

There's no need to run all over town for motoring necessities with this station only a matter of a few minutes from your place.

Here you'll find tires, batteries, gas and the like — our prices are low — service prompt.

We're here to add to your motoring pleasure. Let us start doing it today by filling your tank with Blue Sunoco— the high powered, long mileage motor fuel.

ROGER CONKLIN'S SERVICE STATION
Sunoco *Licensed* Lubrication
18th AVE. AND "H" STREET
BELMAR, N. J.

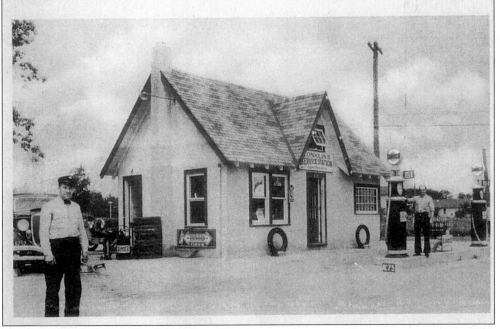

Roger Conklin owned the trailer park and also ran the gas station on the same corner. The advertisement on the card says H Street, which is what Route 71 was called at that time.

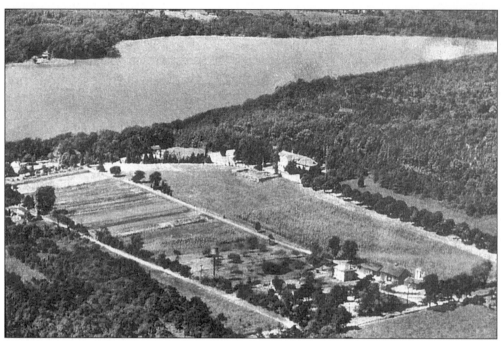

The Margaret and Sarah Switzer Foundation for Girls was located on Ramshorne Drive and Lakewood Road. Today it is the Sunnyside Nursing Home.

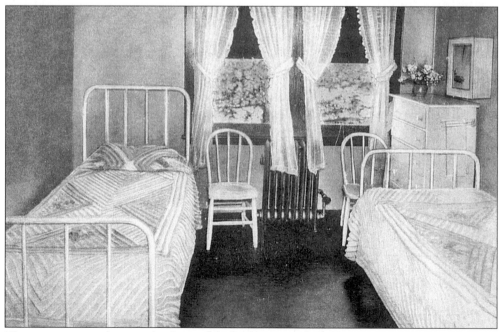

This is an interior photograph of one of the bedrooms in the home.

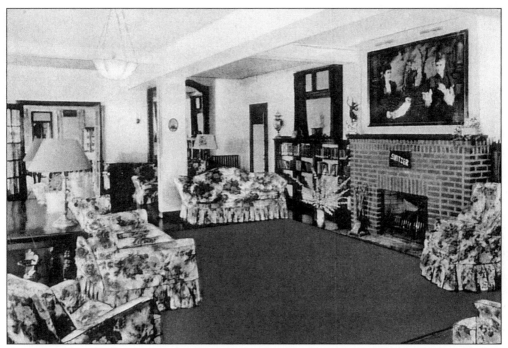

A very comfortable living room for the girls to relax in is shown here. Many of them worked in the vegetable and flower gardens on the property.

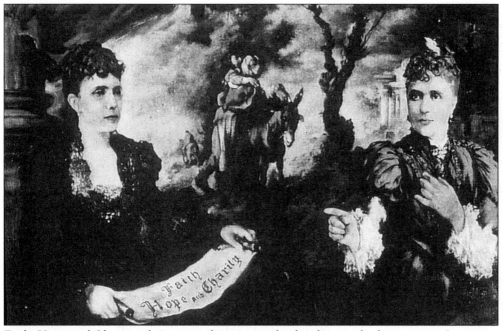

Faith, Hope, and Charity—this portrait hangs over the fireplace in the living room. It pictures Margaret and Sarah Switzer, founders of the organization, in 1922.

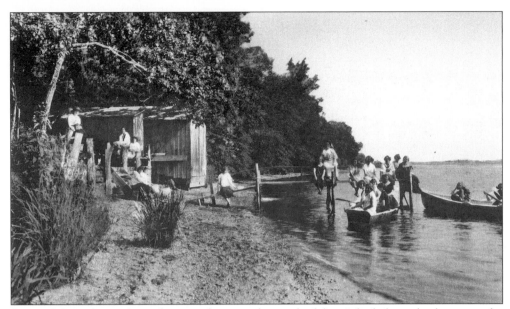

Some of the girls are shown here at play in and near the lake. A little boat shack was on the edge of the foundation property. The girls could go swimming or boating.

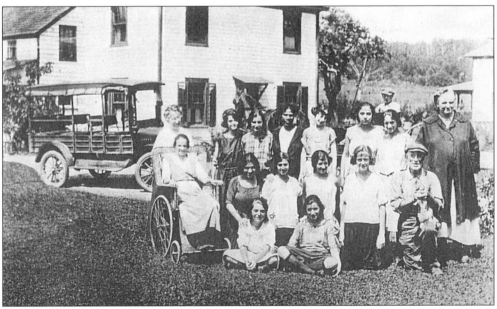

Happy girls pose in front of one of the buildings. The card says, "The Margaret and Sarah Switzer Institute and Home (for girls) Rest Cure."

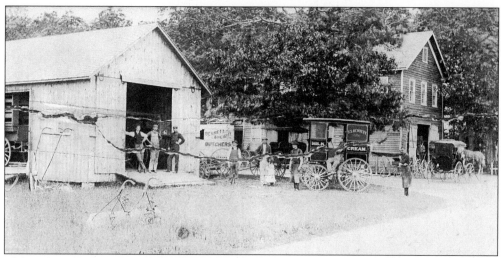

This is the corner of New Bedford and Woolley Roads. The building on the left is a car repair shop today. It was also the Wall First Aid Squad's original building in 1939. The other building, located on the northwest corner of Woolley Road, is no longer there. It was once a wheelwright shop run by Arch Newman.

Terms _____ New Bedford, N. J., _Mar 20_ 187**7**

Mr Jacob Bearmor _____

HARNESS MADE
AND REPAIRED
At short notice.

Bought of **E. S. VANLEER,**

DEALER IN

Dry Goods, Groceries and General Merchandise,

Hardware, Paints and Oils, Boots, Shoes, Hats, Caps, Crockery, Canned Goods, Flour and Feed, &c.

To Mdse Bot & Ballance due to date $80.27

Mr Bearmor

My Dear Sir Above I send you amt due on Book acct to this date I have endeavored to make out without calling on you for money knowing that when you got your money you would pay me but I am so mutch in need of money now that I am obliged to call on you I want to sell you all you may want but I fell that Just now I must have some money if you can possible raise me some My Business demands it and you will confer a great favor beside a Thousand Thanks

My Your Servent E S Vanleer

Vanleer ran the general store in the New Bedford area in the 1870s. This billhead was sent to Mr. Jacob Bearmor as a notice that some money was expected from him.

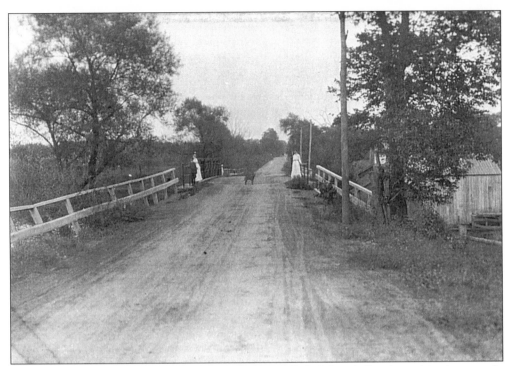

Allaire Road runs east from Rochen's Pond, then called Osborn's Pond, in this photograph. There wasn't much traffic in those days. The little building sign on the right side of the picture says, "Cider."

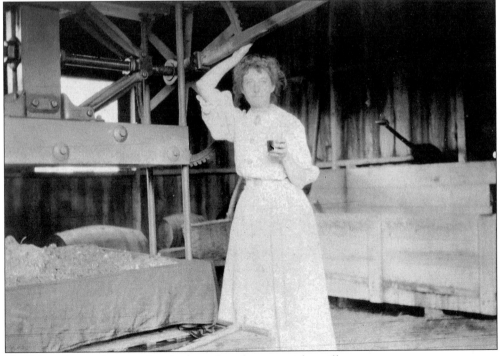

Flo Osborn is seen here tasting the brew from her own cider mill.

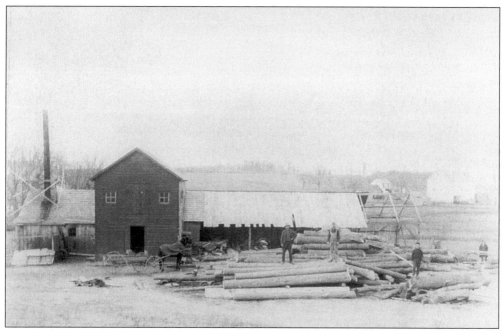

Ezkiel Allgor's sawmill was on Eighteenth Avenue and the Glendola Road area called Taylor's Pond. This picture shows what the sawmill looked like *c.* 1880. (Courtesy of the Old Wall Historical Society and Clifford Allgor.)

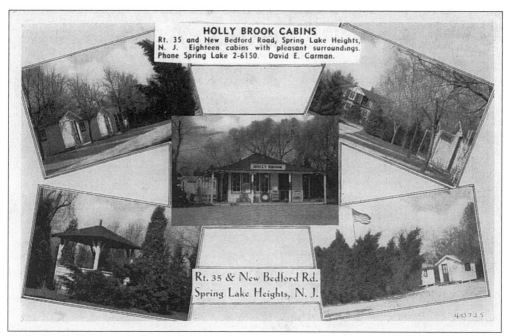

HOLLY BROOK CABINS
Rt. 35 and New Bedford Road, Spring Lake Heights, N. J. Eighteen cabins with pleasant surroundings. Phone Spring Lake 2-6150. David E. Carman.

Rt. 35 & New Bedford Rd. Spring Lake Heights, N. J.

Holly Brook Cabins were located on the southwest corner of Route 35 and New Bedford Road. The card says Spring Lake Heights because of the mail delivery. There is nothing left at the area today except a wooded lot.

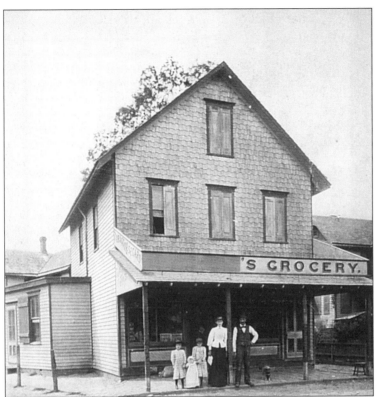

Kings Market, later H.J. Stines, seen in this c. 1900 photograph, was on the northwest corner of Route 71 and Seventeenth Avenue. At one time the building was a harness shop. The post office was established here about 1870 and closed in 1903. An A&P store occupied the building during the late 1930s. (Courtesy of Bob White.)

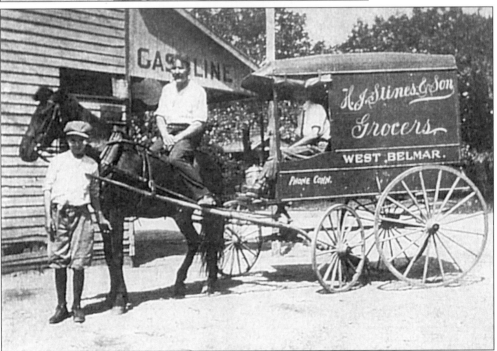

H.J. Stines and son took over the store in the early 1900s. It was also an early gasoline station. On his delivery wagon, it says Phone Conn. (Courtesy of Bob White.)

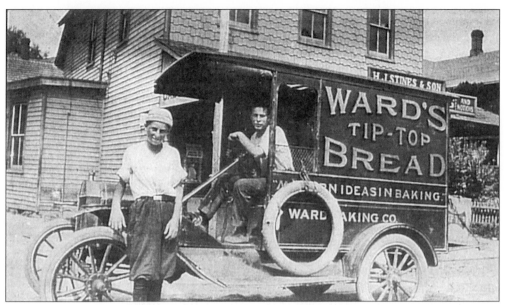

The boy on the left probably helped the regular deliveryman in the truck in order to earn just a few cents a day. (Courtesy of Bob White.)

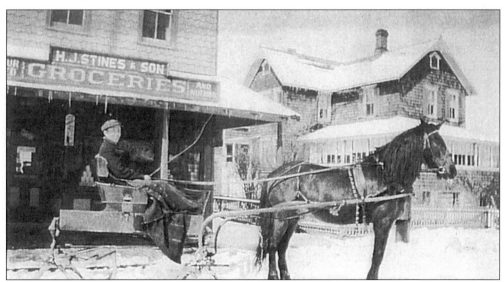

Well, what's keeping her? She's been in the store too long and I am getting cold. The home on the right housed the first Wall Township Library. (Courtesy of Bob White.)

Although there was gas, the old horse was still needed to bring it to the store. Mr. Stine's gas delivery was still relying on a mode of transportation that was fading fast by the time this photograph was taken. The horse wasn't ready to be put out to pasture yet, though. (Courtesy of Bob White.)

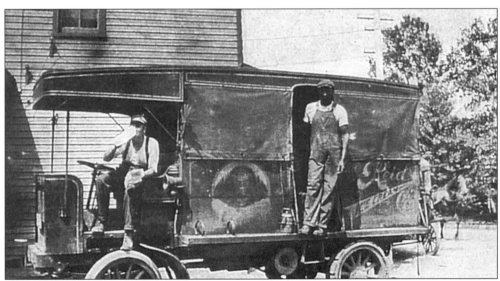

Reids Ice Cream was very popular in those days. Nice Truck! The deliverymen take a break here. (Courtesy of Bob White.)

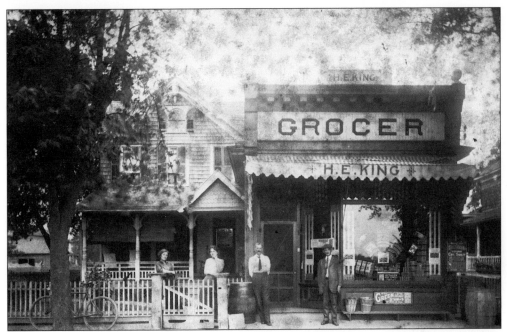

Mr. King moved his store, originally located on Seventeenth Avenue and Route 71, just down the road on Route 71 (or Route 4N, as it was called in days past) to the northwest corner of Curtis Avenue.

Just look at the prices in those days. Mr. King also had another store on Eighteenth Avenue and White Street in South Belmar.

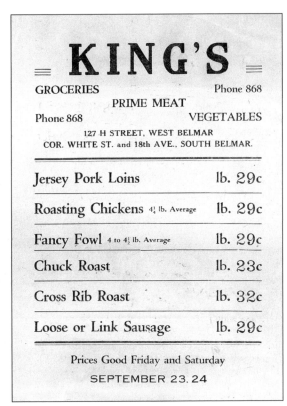

KING'S

GROCERIES		Phone 868
	PRIME MEAT	
Phone 868		VEGETABLES

127 H STREET, WEST BELMAR
COR. WHITE ST. and 18th AVE., SOUTH BELMAR.

Jersey Pork Loins	lb. 29c
Roasting Chickens 4½ lb. Average	lb. 29c
Fancy Fowl 4 to 4½ lb. Average	lb. 29c
Chuck Roast	lb. 23c
Cross Rib Roast	lb. 32c
Loose or Link Sausage	lb. 29c

Prices Good Friday and Saturday

SEPTEMBER 23. 24

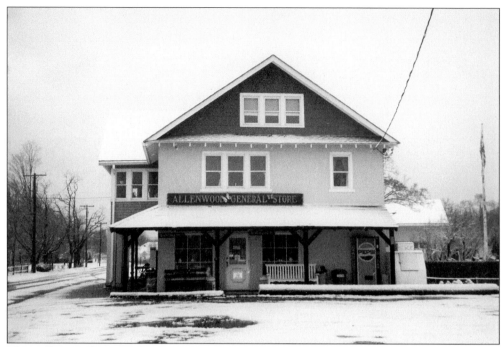

The Allenwood General Store, also called the Country Store, located in the heart of Allenwood, is run by John and June Herbert and family. The store has an antique shop just loaded with old memorabilia and a restaurant with old ice-cream chairs—the rooms are just filled with oldtime atmosphere. Originally, Hall Feimster owned the store and merchandised everything, including coal. (Courtesy of the John Herbert Family.)

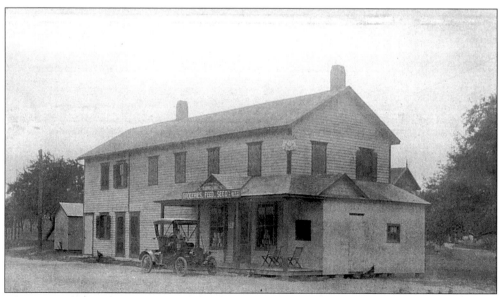

Clarence Hall ran the old general store in Glendola on Belmar Boulevard in the southwest corner of Allenwood Road. Today the building is the Blind Man's Association.

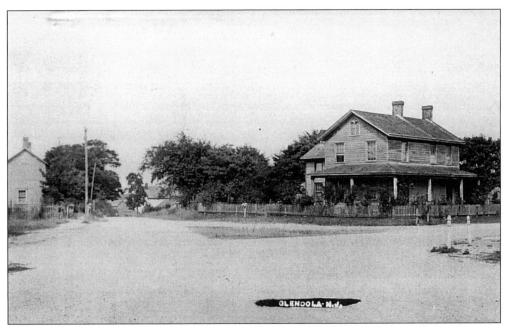

Bartow's Store was on the northeast corner of Belmar Boulevard and Allenwood Road. Harry Hurley has a tile business on that site today. Mr. Charles Bartow purchased this building from W.H. Shafto in 1880. Glendola was called Hopeville in those days. In the 1950s, the Mitchel family ran the store.

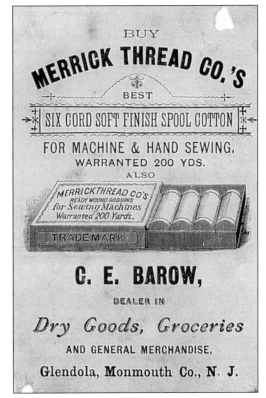

This trade card from the Bartow Store had his name spelled wrong. The Glendola Church was on the other side of the street from the store.

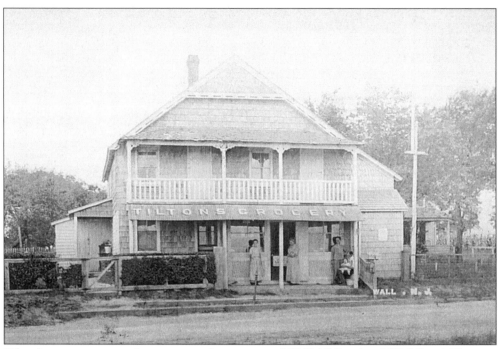

Tilton's grocery or general store was at the junction of Old Mill Road and Wall Road. This was Wall Township in those days. The Wall Church was just north of the store.

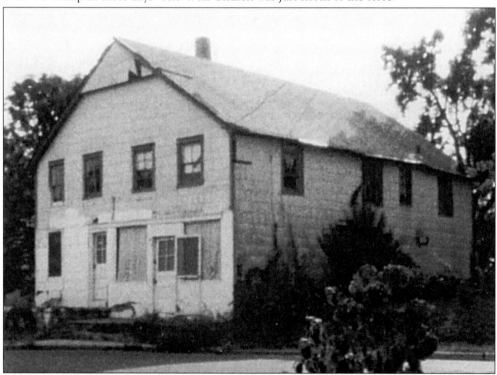

This is the old Tilton Store just before it was torn down in 1985. There is a more recent home on the site today.

J. TILTON,

LAKE COMO, N. J.

—DEALER IN—

Dry Goods, Notions, Stationery,

LADIES' AND GENTS' FURNISHING GOODS, UNDERWEAR,

Groceries, Provisions, Boots, Shoes, Hardware, Glassware, Tinware, Etc.

AGENCY FOR THE UNIVERSAL PATTERNS.

PATTERNS SENT TO ANY ADDRESS, POST-PAID, ON RECEIPT OF THE PRICE. 342

Album of Fashions. 64 Pages, over 1000 Large Illustrations. 20 Cents, post-paid.

SUBSCRIPTIONS RECEIVED FOR THE <u>UNIVERSAL MAGAZINE</u>, ONLY $1 A YEAR.

The area of Tilton's Store was also called Como or Lake Como. Patterns were a big thing back then; women would often make their own clothes because it was a lot cheaper than buying them in a store.

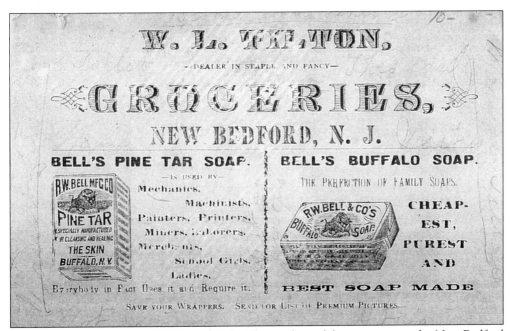

The Tiltons were a very enterprising family. This trade card features soap in the New Bedford Store.

43

E. L. TILTON

—WILL FURNISH—

PURE COUNTRY MILK

➤➤ To + the + Residents + of + the + Park + and + Grove ◀◀

✦ DELIVERED ✦ TWICE ✦ DAILY ✦

——FROM HIS——

Glendola Dairy Farm.

SATISFACTION GUARANTEED.

Another Tilton product was milk. They delivered to the home by horse and wagon.

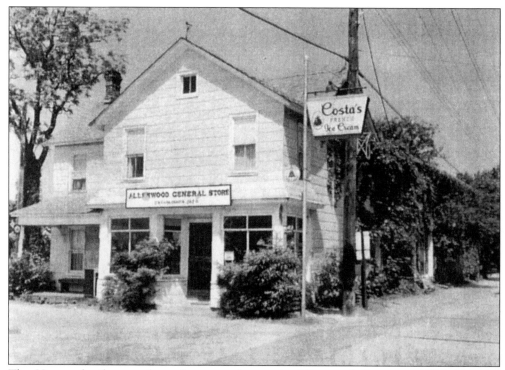

The Havens family started another general store in Allenwood Center in 1876. In 1900, William Allen operated the store; in the 1960s, the Kell family operated an antique store there. Today, it is being renovated for another venture.

Two

CHURCHES
AND SCHOOLS

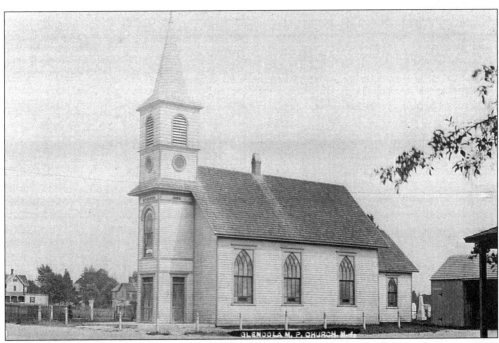

The Glendola Church started on West Hurley Pond Road in the area of the parkway, c. 1813. There was a cemetery by the church, but nothing remains on the site today. The church moved to the southeast corner of Belmar Boulevard and Allenwood Road. It was torn down in July 1967. To the right of the church were stables.

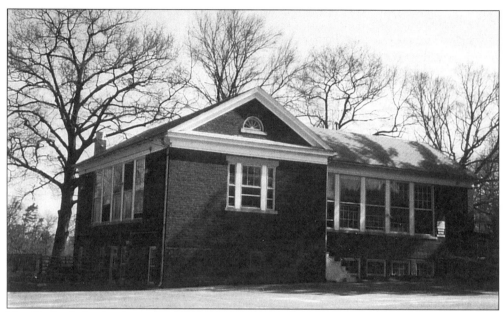

The Hurley School is located on Magill Road, in the northwest corner of Wyckoff Road. Built in 1932, it served the children in the northwestern part of Wall Township until 1982. It replaced an earlier one-room school about a mile west that is now a private home.

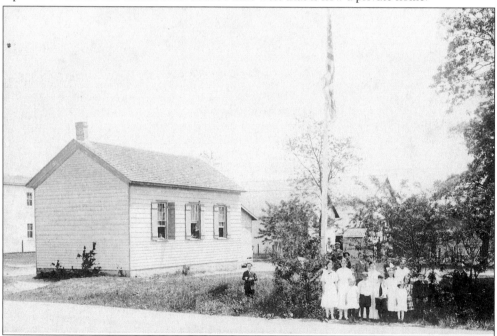

The Blansingburg School has been on Sea Girt Avenue next to Frank Newman's hardware store since the middle of the 1800s. Recently, there was a lawnmower repair shop in the building, but it relocated to allow the building to be moved to the Old Wall Historical Society grounds on New Bedford Road in 1999. The original tin ceilings and blackboards are still intact, and as this book goes to print, the original desks are in storage, awaiting the big move. The school closed in 1936.

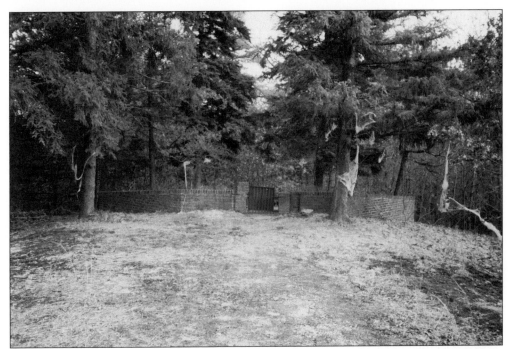

The Arthur Brisbane family cemetery is located on his former estate near Allaire State Park. Mr. Brisbane built a tower on a high hill right near his home as a place where he could relax away from the newspaper business. He could see the ocean and towns as far away as Lakehurst. Mr. Brisbane passed away in 1936. The cemetery is right next to the tower, which burned down in the 1960s.

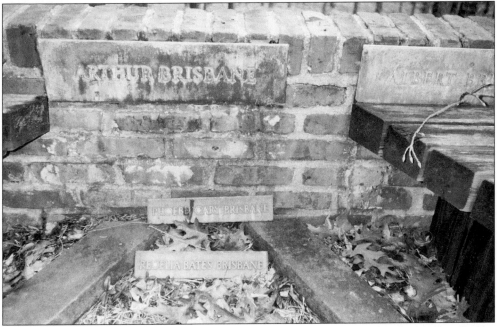

These plaques mark the spot where the family is interred, surrounded by the brick wall. The property is used today for children with special needs.

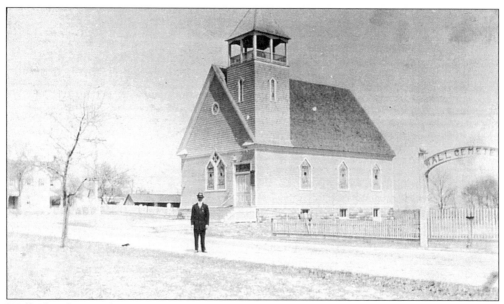

Wall Church is in what is now Spring Lake Heights on Old Mill Road near Wall Church Road. The church got its start in 1834. Women had a separate entrance than the men and were not allowed to sit next to them. A partition in the isle kept them apart. This lasted until the 1890s. Note the nice fence around the cemetery.

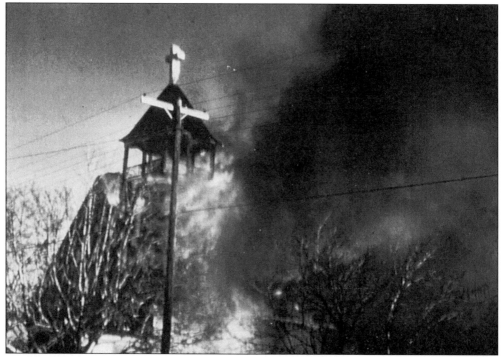

On New Year's Day 1962, the church burned down. It was a sub-zero day and the firemen wore faces of ice. A new church was built on the site.

48

It is believed that the Christ Church in Allaire Village was started before 1830 and that school classes were held in the building. Some teachers also served as pastors of the church. The steeple was built on the rear of the church, which is rare. Today the church is fully restored.

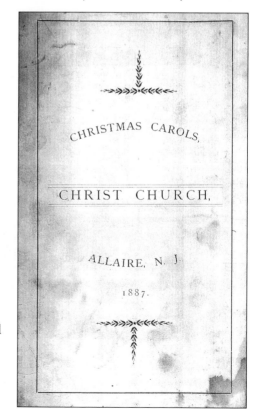

CHRISTMAS CAROLS,

CHRIST CHURCH,

ALLAIRE, N. J.

1887.

This rare cover of a Christmas program held at the church dates back to 1887. The church bell was cast at Allaire. It has been said that Mr. Allaire threw several gold pieces into the molten metal to insure its music would always be worshipful and true. (Courtesy of *Allaires Lost Empire*.)

The West Belmar Church got its start in 1924. E.S.V. Woolley, then president of the West Belmar Fire Company, saw the need for a church in the area and secured the upstairs room of the fire company on Route 71 for Sunday School. Reverend Hill, from Villa Park, was pastor. In 1925, the West Belmar Church was built at Seventeenth Avenue and I Street. (Courtesy of Bob White.)

In 1960, ground was broken for the new E.S.V. Woolley Educational Building located next to the church. This new hall serves not only the Sunday school, but provides a meetingplace for organizations, church suppers, and special programs. (Courtesy of Bob White.)

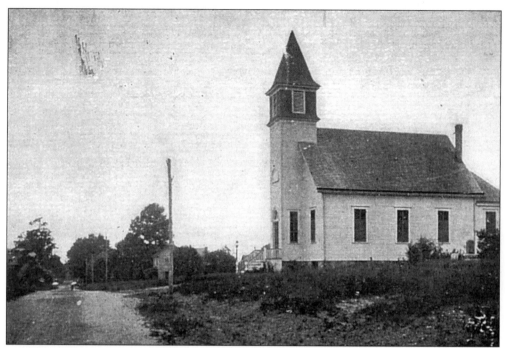

In 1857, the Methodist class group used the old schoolhouse as a meetingplace to organize a local church. In 1859, the Allenwood Church was finished, located a little east of the present one.

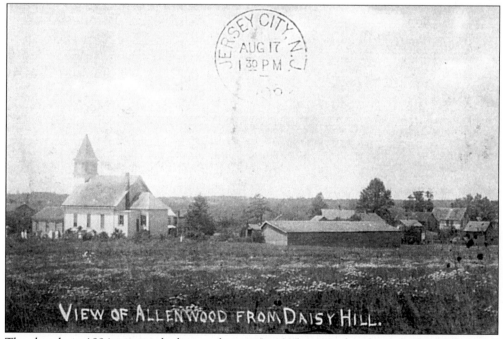

VIEW OF ALLENWOOD FROM DAISY HILL.

The church, in 1894, was in a bad state of repair. In 1895, a new church was built in Allenwood that is still being used today. This is a view from the field in back of the church. Today, homes have been built on the site.

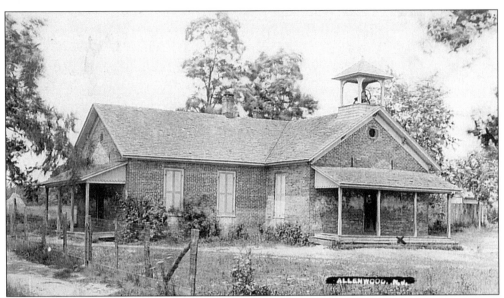

The Allenwood School was reported in the *Sea Side* newspaper of Manasquan on April 18, 1884, as being equipped with Baker and Pratts Triumph Desks and other furniture to accommodate 80 scholars. Today, this building is the home of the Richard Tatum family. The following passage is from a diary kept by Dr. Robert Laird, the Wall Township superintendent of public schools from March 1851 through March 1866: "April 19, 1865, I visited the following schools: Manasquan, Pearces, New Bedford and Blansingburg. Announced the death of the President of the United States, Abraham Lincoln. Requested the teachers to close their schools and give the pupils and teachers an opportunity to attend the funeral services at Squan Village. It was so done." (Courtesy of the Old Wall Historical Society.)

The New Allenwood School was built across the street from the older school. This *c.* 1930 photograph does not reflect the additions built onto the original structure.

One of the early Wall Township schools was the Como School on Route 71 just north of St. Clair Avenue, which is now a part of Spring Lake Heights. It was built in the 1800s to serve Wall children of that area. The school was razed in the 1980s; new homes have since been built on the site.

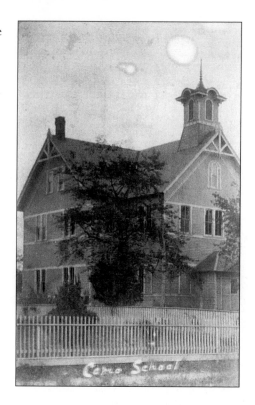

This Como school report card of the year 1909 is signed by principal H.W. Mountz. He later became the first principal in the new Spring Lake school on Tuttle Avenue in Spring Lake. After he passed away, the school was named after him.

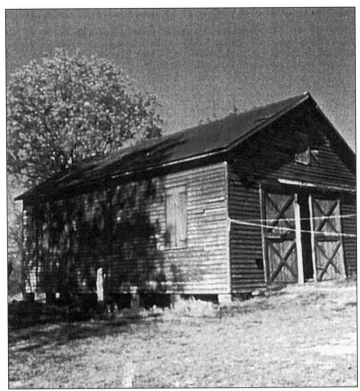

This is what remains of the Chapel (now Glendola) schoolhouse built on Allenwood Road c. 1830 and last used in 1906. The building was moved to Woodfield Avenue and used mostly for storage. Mr. Robert White tried to save the building but his efforts failed and they tore it down in 1965. (Courtesy of Bob White.)

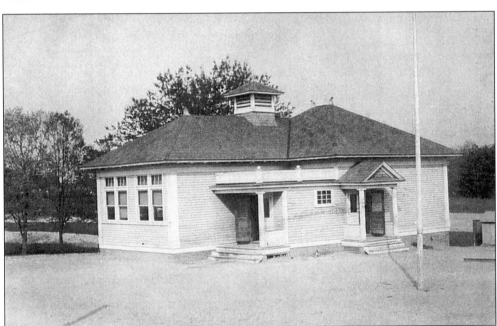

This Glendola schoolhouse was built on Allenwood Road near the early one, which was located near the entrance to Saint Mary's Cemetery. In 1913–14, Alvin W. White was principal of the school; he is also the grandfather of former Wall Township Historian Robert White. Today the school is the Willow Tree Nursery School. (Courtesy of Bob White.)

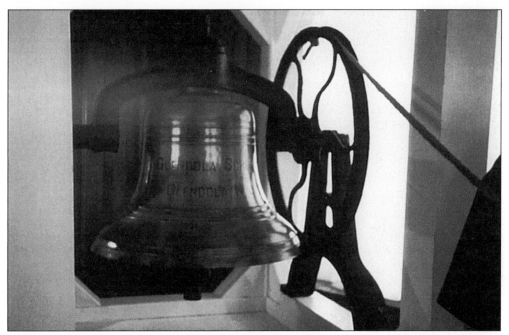

This Glendola school bell was recently found in the basement of a school; Dan Buckley, a student at Wall High School, refurbished it as an Eagle Scout project. It is now at the Old Wall Historical Society. (Courtesy of the Old Wall Historical Society.)

The West Belmar School was built at Seventeenth Avenue and I Street in 1890. Prior to that, area children went to school in New Bedford. Before any additions were put on, the graduation commencement was held at the West Belmar Church. It holds classes from kindergarten through the fifth grade. (Courtesy of Bob White.)

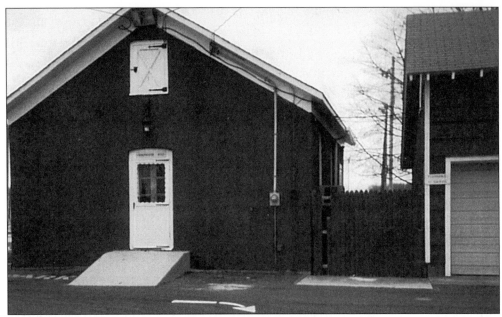

The older New Bedford schoolhouse was built on Eighteenth Avenue, east of New Bedford Road. In 1897, when the town built the new school, it was moved behind the old one. Today, it is used as a transportation office for the board of education. This building was the first Wall Township Police Headquarters; Police Chief Vernon Shibla had an office in it.

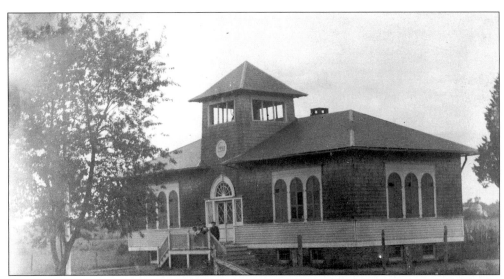

The new schoolhouse in New Bedford was built on this site in 1897 and was used until 1950. Mary Redmond taught 33 children for a salary of $405 per year. In 1907, J.C. Tilton taught 31 pupils in the upper grades for a yearly wage of $540.

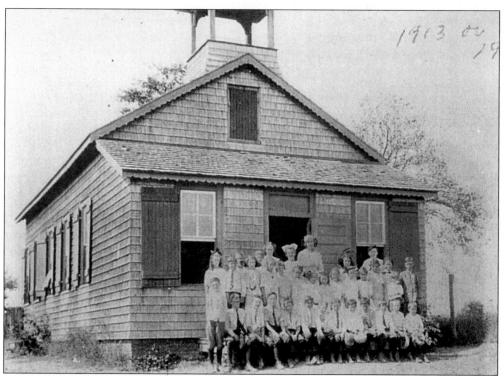

1913 oct 19

The Bailey's Corner School was built *c.* 1860s. Today the school, located at 405 Bailey's Corner Road, is a private residence; one would never recognize it was a school because of the many renovations.

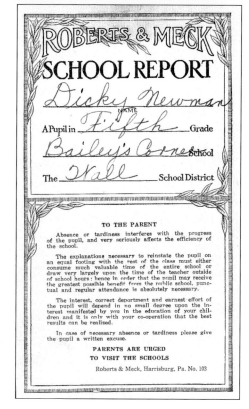

ROBERTS & MECK

SCHOOL REPORT

Dicky Newman

NAME

A Pupil in *Fifth* Grade

Bailey's Corner School

The *Wall* School District

TO THE PARENT

Absence or tardiness interferes with the progress of the pupil, and very seriously affects the efficiency of the school.

The explanations necessary to reinstate the pupil on an equal footing with the rest of the class must either consume much valuable time of the entire school or draw very largely upon the time of the teacher outside of school hours; hence in order that the pupil may receive the greatest possible benefit from the public school, punctual and regular attendance is absolutely necessary.

The interest, correct deportment and earnest effort of the pupil will depend in no small degree upon the interest manifested by you in the education of your children and it is only with your co-operation that the best results can be realized.

In case of necessary absence or tardiness please give the pupil a written excuse.

PARENTS ARE URGED
TO VISIT THE SCHOOLS

Roberts & Meck, Harrisburg, Pa. No. 103

This is what the cover of a report card looked like in June 1936. Mr. Newman was promoted to the sixth grade. The teacher was Anna H. Rash.

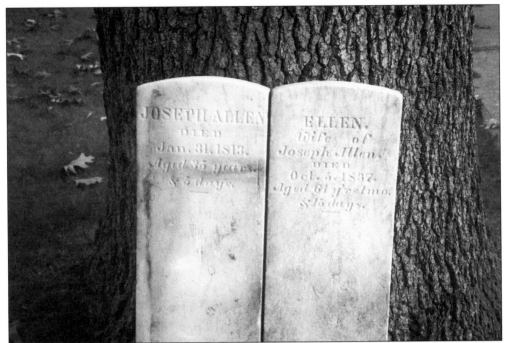

The Joseph Allen Cemetery no longer exists. It was formerly located on a bluff overlooking the Manasquan River at the end of Frazee Drive and River Road. The property owners gave these stones to Robert White, who, in turn, donated them to the Old Wall Historical Society in 1998. (Courtesy of Bob White.)

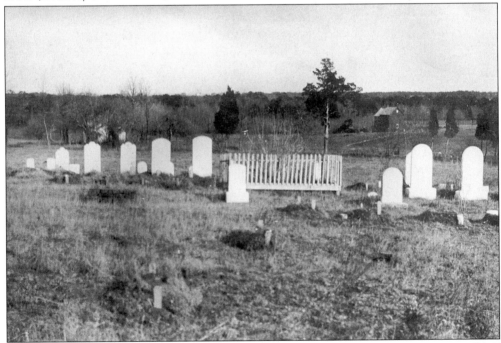

The Bearmore's Cemetery is on Route 35 across the highway from K-Mart. It sits on a small hill at the entrance to the trailer park. There are many early Wall Township residents buried here.

Three
HOMES AND FARMS

The Allgor-Barklow homestead dates back to about 1800. James L. Allgor owned the house in 1844 and operated a store in the front room. His daughter Lavinia married Matthias A. Barkalow; their family lived in the house after Lavinia's father died. The building has been operated as a museum by the Old Wall Historical Society since 1981. (Courtesy Dick Hurley and the Old Wall Historical Society.)

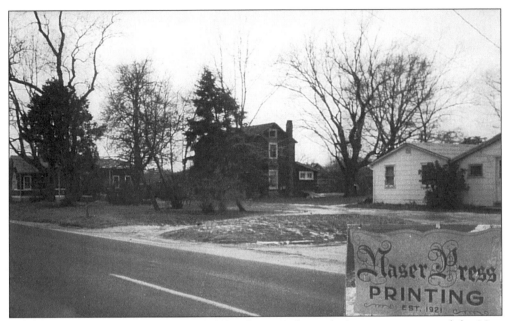

The home of the late Frank Naser and family on Eighteenth Avenue, just east of the New Bedford School, can be seen on the left side of this picture. The building on the right is where Mr. Naser had his print shop from 1921 until the 1970s. The Wall Board of Education purchased the property and demolished the buildings in January 1999.

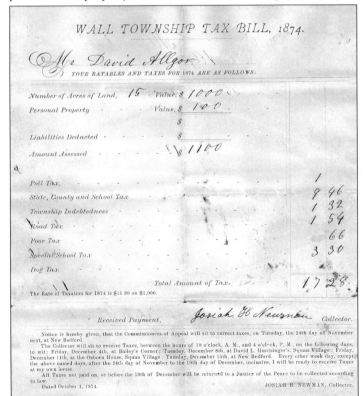

WALL TOWNSHIP TAX BILL, 1874.

Mr. David Allgor

YOUR RATABLES AND TAXES FOR 1874 ARE AS FOLLOWS:

Number of Acres of Land,	15 Value, $	1000
Personal Property	Value, $	100
	$	
Liabilities Deducted	$	
Amount Assessed	$	1100
Poll Tax,		1
State, County and School Tax		9 46
Township Indebtedness		1 32
Road Tax		1 54
Poor Tax		66
Special School Tax		3 30
Dog Tax		
Total Amount of Tax.		17 28

The Rate of Taxation for 1874 is $11 80 on $1,000.

Received Payment, Josiah H. Newman Collector.

Notice is hereby given, that the Commissioners of Appeal will sit to correct taxes, on Tuesday, the 24th day of November next, at New Bedford.
The Collector will sit to receive Taxes, between the hours of 10 o'clock, A. M., and 4 o'ck, P. M. on the following days, to wit: Friday, December 4th, at Bailey's Corner; Tuesday, December 8th, at David L. Huntsinger's, Squan Village ; Friday, December 11th, at the Osborn House, Squan Village ; Tuesday, December 15th, at New Bedford. Every other week day, except the above named days, after the 24th day of November to the 19th day of December, inclusive, I will be ready to receive Taxes at my own house.
All Taxes not paid on, or before the 19th of December will be returned to a Justice of the Peace to be collected according to law.
Dated October 1, 1874. JOSIAH H. NEWMAN, Collector.

David Allgor, listed as owner of the property in 1874, was Frank Naser's grandfather. At that time, there were 15 acres; the taxes were only $17.28.

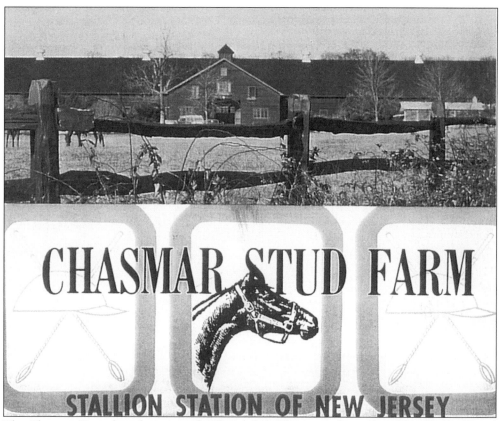

The Chasmar Farm, later known as the Spring Lake Farm, was located on New Bedford Road and Route 35, where the A&P store is today. The large old barn was used as a stable and also had an apartment in it. The building was constructed from a Sears and Roebuck Kit. It was torn down in the 1980s. (Courtesy of Bob White.)

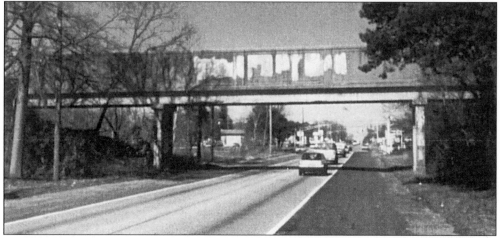

This bridge, called the Horse Bridge, went from the Chasmar Farm over Route 35 to the area where Spring Lake Gardens is today. The bridge was a passageway for the horses so as not to endanger them while en route to the pasture on the other side of the highway. The bridge was demolished on the night of February 26, 1986.

61

The Parks Tatum Farm is at 3217 Atlantic Avenue in the Allenwood section of Wall. Grandparents of Mrs. Parks Tatum, Albert and Florence Sherman Woolley, started the farm in the 1890s. This picture was taken before the home was renovated.

Some of the produce grown on the farm sits next to Parks Tatum's pickup truck in this photograph. They grew a variety of different vegetables.

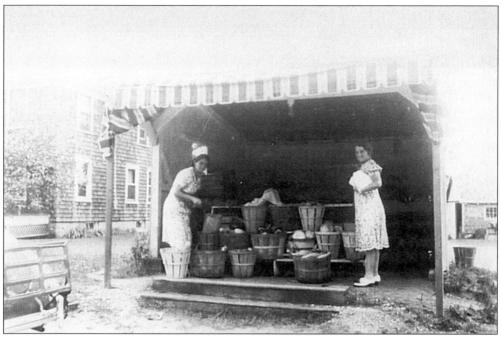

This early view of the farm retail market on Atlantic Avenue shows that ladies wore nice dresses to go shopping in those days. (Courtesy of the Parks Tatum Family.)

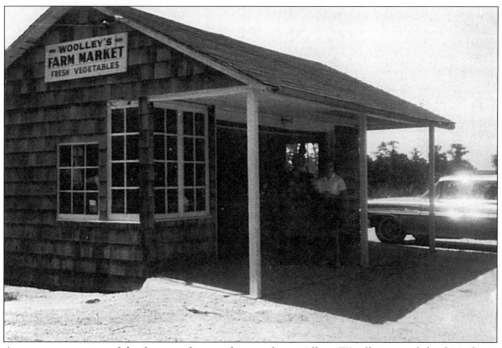

A more recent view of the farm market can be seen here. Albert Woolley passed the farm down to his son Earl; later Mr. & Mrs. Parks Tatum ran it. Today, Mrs Tatum raises some flowers and raspberries as Atlantic Farms does the rest of the farming now. (Courtesy of the Parks Tatum Family.)

The Twin Oaks farmhouse is on the north side of Wall Church Road, between Route 35 and New Bedford Road. Robert Heulitt purchased 244 acres of land in 1843. His son, Capt. Thomas R. Heulitt, built the house c. 1850. Captain Heulitt's son, Robert Laird, raised his family on this farm and sold it in 1915. Dick Hurley, who donated this photograph and many others, is a member of the Heulitt family.

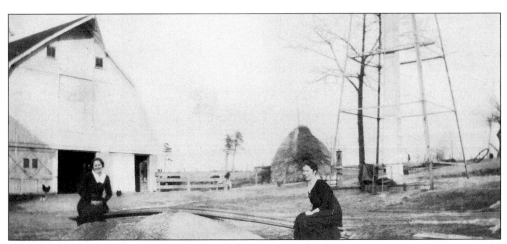

The new barn at Twin Oaks Farm was built when the old barn, built of ships timbers, burned in 1907. There was also an icehouse on the farm to store ice from the pond. (Courtesy of Dick Hurley and the Old Wall Historical Society.)

Miss Althea Heulitt rests under the oak trees for which Twin Oaks Farm was named. (Courtesy of Dick Hurley and the Old Wall Historical Society.)

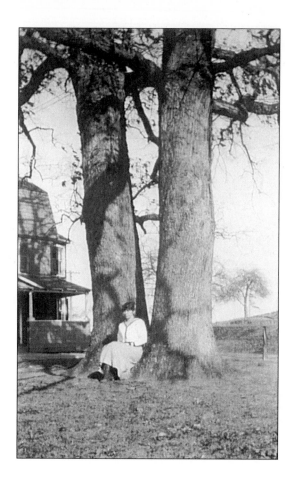

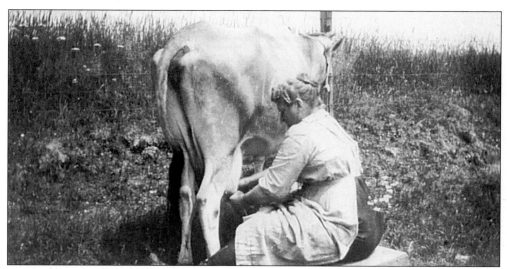

Martha Mount Heulitt and her husband, Robert L. Heulitt, raised ten children on the Twin Oaks Farm. Here, the camera caught Martha Heulitt milking her cow in the yard of the farm. (Courtesy of Dick Hurley.)

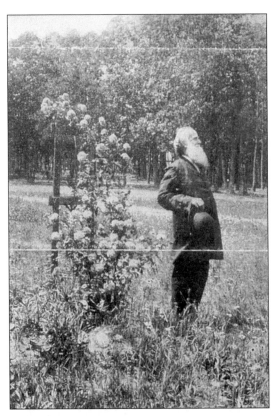

Bishop L.B. Heller, founder and president of America World Camp Meeting, stands among his roses in the West Belmar section of the park. Heller's Park was laid out in 1899 to contain 42 acres. Mr. Heller, an evangelist, erected a tabernacle near his home where religious camp meetings were conducted from July through September each year. (Courtesy of Bob White.)

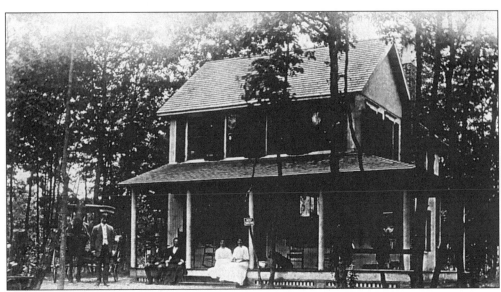

The Peter John Heller homestead was located between Fourth and Fifth Avenues, east of America Street. Lots were advertised from $200 and bungalows from $500 and up. Peter John Heller was the brother of Bishop L.B. Heller. (Courtesy of Bob White.)

This simple cottage, located at 1916 Camp Meeting Street in Heller's Park, was one of the first erected. Mr. Heller preached "Tranquillity, Peace, and Prohibition." The prohibition of saloons and gambling was the main objective. (Courtesy of Bob White.)

This nice old farmhouse no longer stands. It was the Clayton homestead, located on the southeast corner of Belmar Boulevard and Glendola Road.

A handwritten note on the back of this picture says, "Great-great-grandmother Betsy Herbert Heulitt's home in Allaire Spring Meadow. I was married here October 27, 1934. This is the way it looked when mother lived." Mr. Dick Hurley, a relative to the Heulitts, researched his family history and found the writer of the note, Valetta Bennett, was married that day to Ray Burdge.

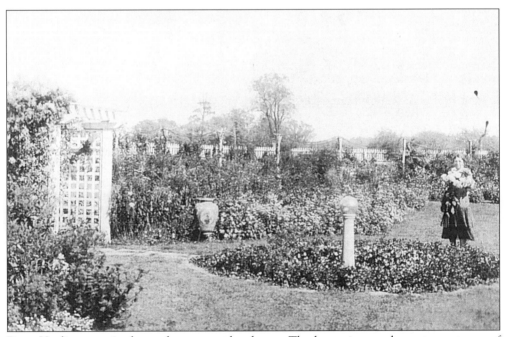

Betsy Heulitt poses in the garden next to her home. The home is now the restaurant area of Spring Meadow Golf Course on Atlantic Avenue.

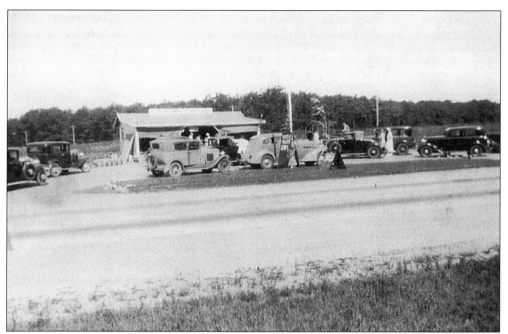

Schanck's Farm Market was located on Route 35 in Wall in the 1930s. Mr. Arthur Schanck operated it just south of Wall Church Road. The family had another farm market in the 1960s and '70s, located further south on Route 35, across from where Old Tudor Village is today. (Courtesy of the Bud Schanck Family.)

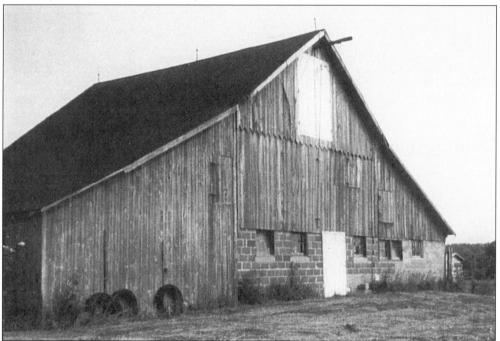

One of Wall's oldest barns is on West Hurley Pond Road. The Conover family operated a dairy farm there for many years. The barn was built c. 1850s from the timbers of old shipwrecks and the first bridge that went over Shark River.

William Hill's summer home on Squirrel Road in Shark River Manor was one of the first built in the area, c. 1930s. The hand pump was used for water, since Wall Township did not yet have a water works (there was another pump for public use on Hillview Road). The home has been enlarged and is still in the same family. (Courtesy of Ted and Della Hill.)

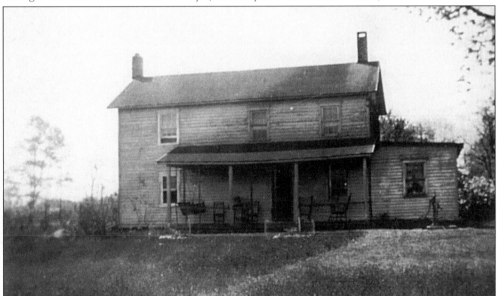

Mr. and Mrs. Frank Derres purchased the farm at 3417 West Hurley Pond Road from the Denningers in 1923. The property was 15 acres and spanned both side of the road. Mr. Arthur Brisbane had an easement on the west side of the property so he could drive his wagon to his estate. The easement was good as long as he used the dirt road once a year. The home was torn down in March 1999 and a new home is being built on the site. (Courtesy of Edith Derres.)

These cabins were at the entrance to Bearmore's Trailer Park on Route 35, across from K-Mart. The Bearmore Cemetery is on the little hill to the right. The cabins, which are no longer there, were owned by Jerry Marvica.

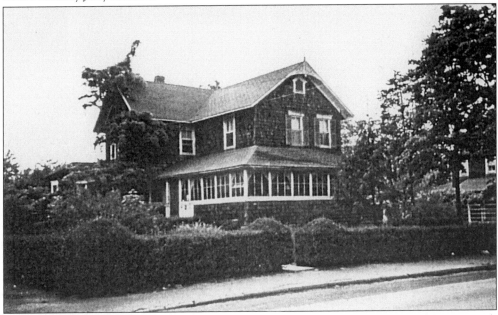

The Stine family resided at 1631 Route 71 and operated a store on Route 71 and Seventeenth Avenue. In 1927, Sarah Elizabeth Stines established a library for the Wall residents in her home; books were circulated by the Monmouth County Library in Freehold. The library remained in use here until around 1959, when a much larger one was established at the Old New Bedford School building on Eighteenth Avenue. (Courtesy of Bob White.)

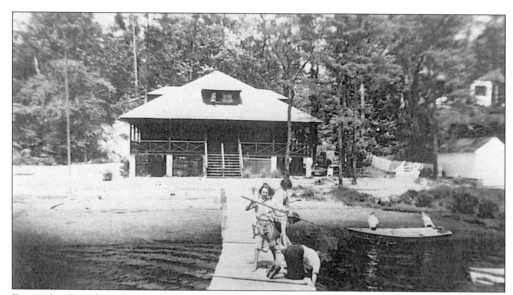

Evangelist Dwight Moody built the Manasquan Park Club House *c.* 1900 after purchasing land from the Osborn family, who farmed the area. Mr. Moody wanted to create a religious community here and held Sunday services in the building. Each property owner in the area has the right to use the land, which is at the end of Myrtle Avenue and Riverside Terrace, on the shore of the Manasquan River. The building burned down in the 1980s. (Courtesy of Bob White.)

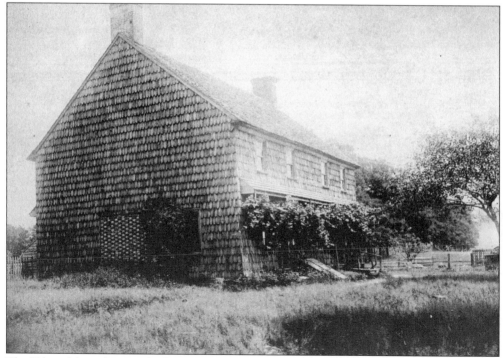

The Tilton-Morris home, which was originally on Tilton's Corner Road, was moved just around the corner to face Sea Girt Avenue. Parts of the home were built in the early 1700s. The road was named after the Tilton family. (Courtesy Marilyn B. Mazella and Jackie L. Davin.)

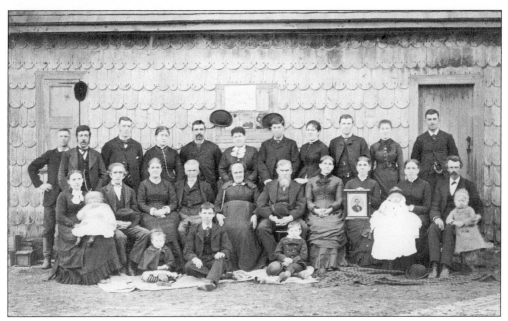

The Morris family is shown here along with Robert Blaine (a workman) on Christmas 1882. Also posing here are members of the Hulsart, LaFetra, Morton, and Reynolds families. (Courtesy Marilyn B. Mazella and Jackie L. Davin.)

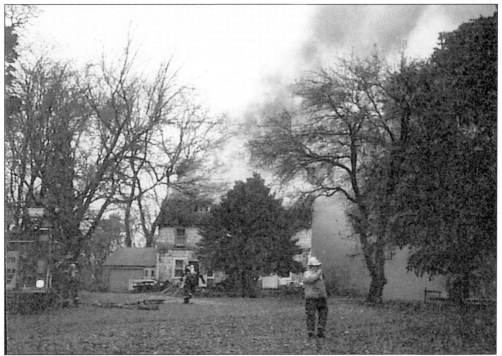

In 1800, Abigail Tilton married James L. Morris. Their son, Thomas Morris, lived in the home above until 1909. In 1968, Mr. George Meehan, a lawyer in Spring Lake Heights, purchased the house. This picture shows the moment flames broke through the roof on November 21, 1996, and destroyed the old home.

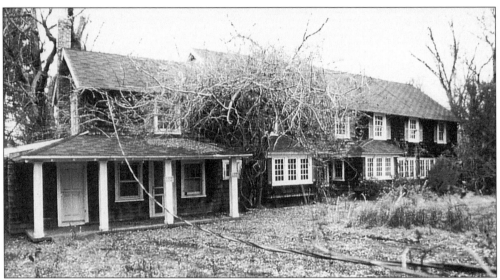

The Pearce-Brown-Bennett Farm, last known as Bennett's Orchards, was on Route 35 opposite Church Street. Before Route 35 was built, Meetinghouse Road went by the homestead. Deed research by the Old Wall Historical Society indicates that the site was owned in the early part of the century by Asher Pearce and sold to Morris Brown, who is listed as the owner in 1851. In 1912, Edwin A. Bennett purchased the property and it was handed down to his son, James F. Bennett. (Courtesy of the Old Wall Historical Society.)

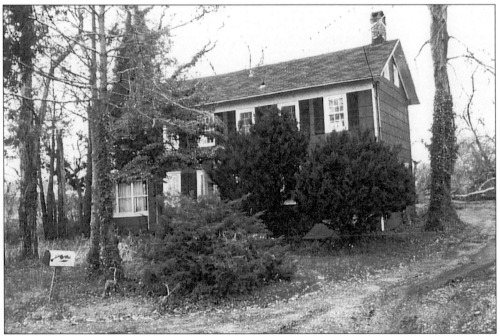

This home sat on the west side of the dirt road that ran from Route 35 into the farm. It was the earliest farmhouse built there. Everything was torn down in November 1997. There are new homes on the old orchard site today.

This billhead shows that Mr. Bennett used a lot of gasoline and oil in 1922. He not only used it for his auto, but also for his tractors back at the farm.

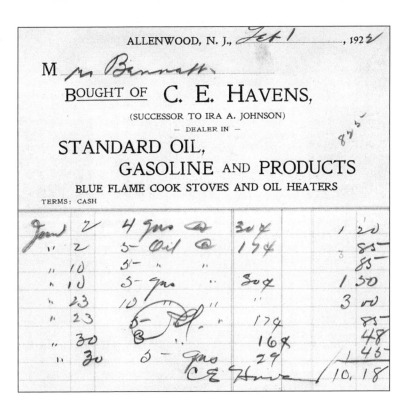

This 1914 billhead came from a grain dealer in Manasquan. Mr. Wycoff even had the courtesy of writing, "Thanks," on the bill after it was paid.

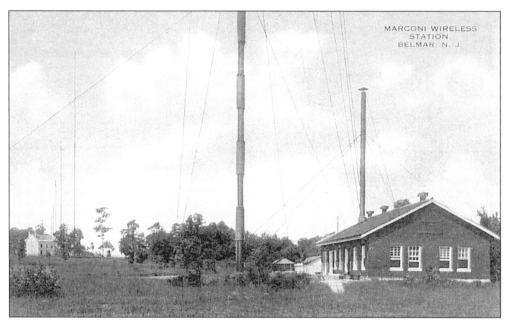

The Stanton-Woolley-Callas farmhouse is located at 1101 Monmouth Boulevard. It was originally situated several hundred yards east on what is now Camp Evans property, which was once and will be a part of Wall again. The home, on its original site, is pictured here on the left. Joseph Stanton built the house *c.* 1843. His daughter Adelia married George P. Woolley; they raised eight children in the farmhouse. In 1913, the Marconi Wireless Company purchased the home. It is being remodeled at this time. (Courtesy of the Old Wall Historical Society.)

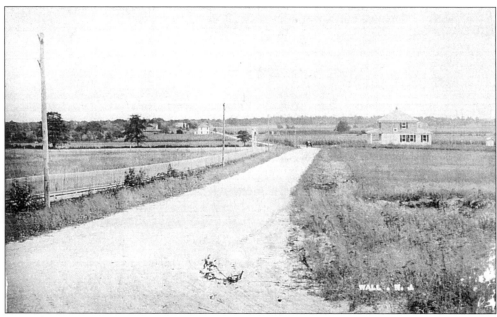

An early view of Wall Road looks east from Old Mill Road. Wall Road was just a dirt path for wagons at the time. The fence on the left surrounds the Wall Church Cemetery. The home on the right is 1217 Wall Road. This area was in Wall Township until 1927.

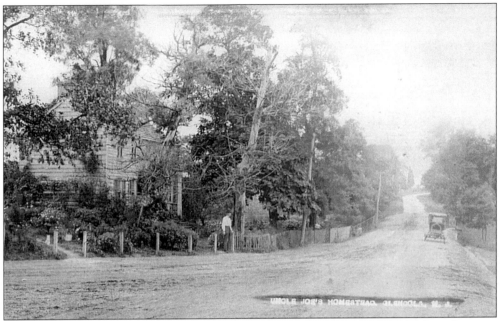

Uncle Joe Morris lived in this log cabin at 1513 Allenwood Road on the west side at the point of Gully Road. A newer home is located there today. The car in the picture is that of photographer Mr. Merriman of Howell Township. His auto is visible in many of his postcard views.

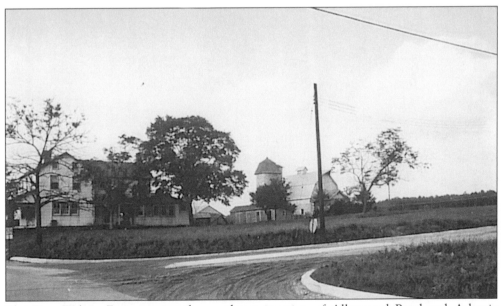

The Pete Wilson Farm was on the northeast junction of Allenwood Road and Atlantic Avenue. For many years, Mr. Wilson plowed the fields around his farm and picked up anything that caught his eye. Many of the articles he found were Native-American artifacts. The house still stands today. (Courtesy of Bob White.)

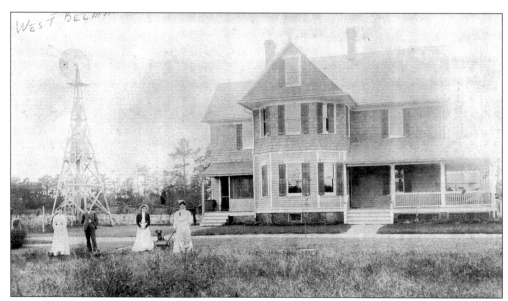

James Wolcott Newman resided at 1127 Eighteenth Avenue, in the West Belmar section, on a large tract of land bordering the America World Camp meeting grounds. After the property was subdivided and developed, road names such as Cottage Place, Central Avenue, and Meadow Road appeared. Mr. and Mrs. Newman and some friends posed for this photograph c. 1900. (Courtesy of Bob White.)

James Wolcott Newman and his son Karl are shown at their Eighteenth Avenue residence c. 1910. Karl P. Newman became the mayor of Wall Township in 1945. The 1906 Maxwell automobile was one of the first in the area. (Courtesy of the Karl P. Newman Family.)

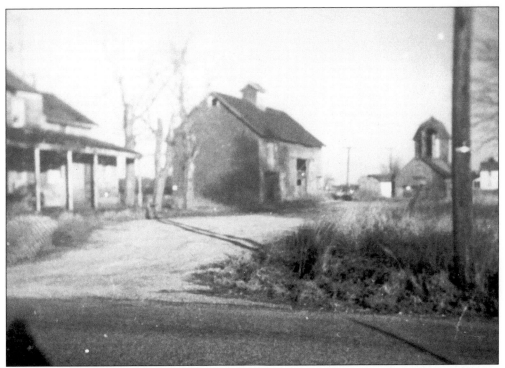

The Josh Robinson Farm was on the southeast junction of Allaire Road and Bailey's Corner Road opposite the Wall Police Department. Mr. Robinson was a typical farmer who raised cows and pigs.

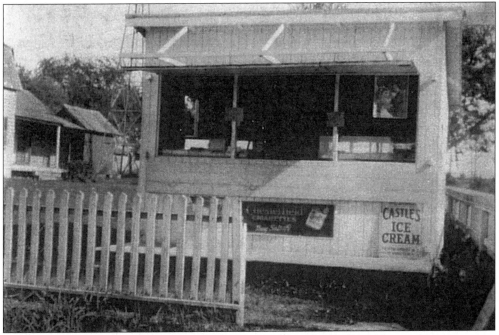

This roadside stand was near the Robinson Farm. All the buildings were torn down long ago. The land is still used by a local farmer who grows mostly soybeans.

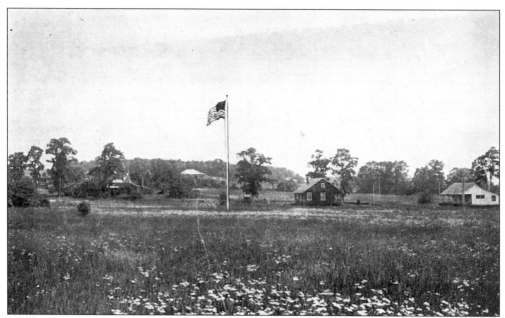

During the 1920s, Manasquan Park did not look like it does today. These two views give us an idea of what it did look like in years past.

In the 1930s, Evangelist Dwight L. Moody decided to sell the property. A local real estate firm started to sell off the lots. They sold slowly until after World War II, when building increased.

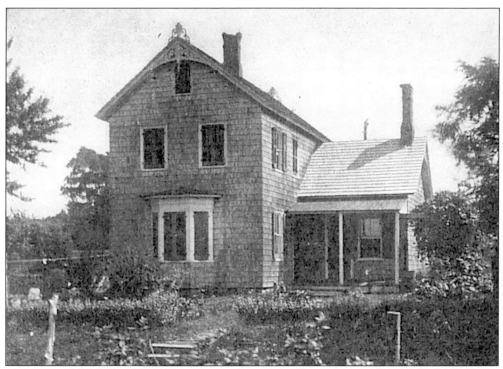

This home, located at 2232 Ramshorne Drive, is a private residence today. In the early part of the century, it was the parsonage for the Allenwood Church.

This is the present parsonage of the Allenwood Church, just opposite the church at 3109 Atlantic Avenue. The Reverand Jim Jorden and family now reside in it.

The Allen-Ferguson homestead dates back to 1790. It was first located on the banks of the Manasquan River, but was moved *c.* 1850 to its present location at 2222 Ramshorne Drive. Note the dirt path, which was then called Mud Creek Road. (Courtesy of the Old Wall Historical Society Pictorial Guide.)

This is another example of the fine homes in the Allenwood section of Wall Township. The lawn looks neatly cut and trimmed. Lawn mowers were pushed by hand in those days.

Four
POST OFFICES,
BANKS, AND
RAILROAD STATIONS

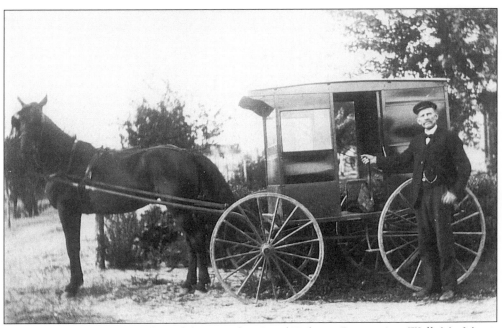

E. Brooks Morris stands ready to deliver mail in Rural Delivery Route #1 in Wall. Mr. Morris was a regular carrier from February 1, 1904, until June 6, 1915. Frank R. Cogovan then took over the route. (Courtesy of the Old Wall Historical Society.)

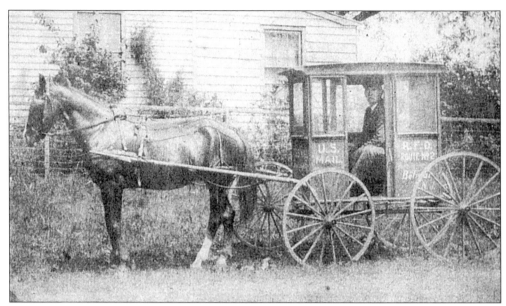

Charles T. Clayton was the first regular carrier on Rural Route #2 in Wall Township. He worked the route from September 1903 until December 1911.

The Manasquan Park Post Office was established in a small general store at 1599 Holly Boulevard, on the corner of Ramshorne Drive. Today it is a private home. Wilhelmina Brewer was postmistress from July 28, 1924, until her death in 1932. Her son, Robert Brewer, then took over the duties until the office was closed in July 1933.

One of the main roads from the north of Wall was Gully Road. E.R. Haight ran this stage line. When it hit the Neptune area, it stopped at the Trap Hotel in Hamilton, then traveled down Gully Road to the New Bedford Hotel, moved on to Mrs. Bailey's Hotel at Bailey's Corner Road and Allaire Road, and then continued on to Manasquan.

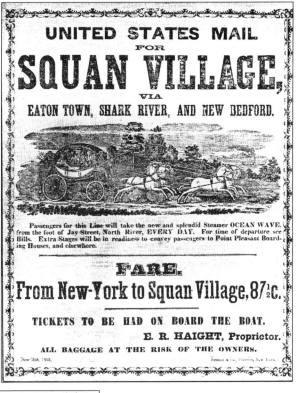

Stagecoach Rules

THESE RULES FOR stagecoach passengers are from the Wall Historical Society archives:

The best seat is the forward one, next to the driver. If you have tendencies toward stage sickness when riding backwards, you'll get over it quick in this seat and receive less jolts and jostling.

If the stage team runs away or you are pursued by Indians, stay in the coach and take your chances. Don't jump out for you will be either injured or scalped.

In cold weather abstain from liquor, for you are subject to freezing quicker if under its influence than as though you were cold sober.

But, if you are drinking from a bottle, pass it around. it is the only polite thing to do. Be sure to procure all stimulants before leaving (Dodge City or Fort Elliott) for the ranch station whiskey is not nectar.

Don't smoke a strong cigar or pipe on the stage, especially when women or children are present. If chewing tobacco, spit to the leeward side.

Don't swear, snore, or lop over on neighbors when sleeping. Let others share the buffalo robes provided in cold weather.

Don't discuss politics or religion. Don't point out sites where robberies or Indian attacks have taken place.

Don't shoot firearms for pleasure while enroute as it scares the horses.

While at stations, don't lag at wash basins or privies. Don't grease hair with bear grease or buffalo tallow, as travel is very dusty.

Don't imagine you are going on a picnic, for stage travel is inconvenient. Expect annoyances, discomfort, hardships. Bear them with fortitude. Be friendly and helpful to other passengers, and your trip will be a pleasant one.

Mr. Haight lived on the northeast corner of Eighteenth Avenue and Glendola Road. The stage and horses were kept in the barns there. The Marshmeadow Farm, located at 357A Glendola Road, is now owned by the Polunas family. The rules of the stagecoach are shown here, for those wondering what it was like to travel on one. (Courtesy of the *Herald* Newspaper (1996) and the Old Wall Historical Society.)

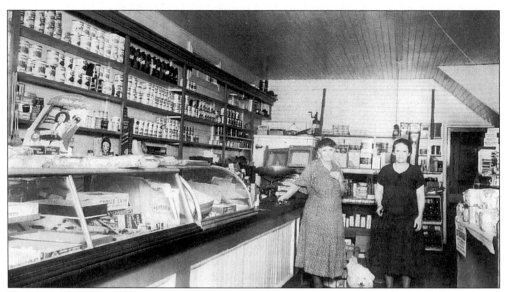

The Villa Park Post Office was established in February 1892 at 308 Route 71 (then Manasquan Turnpike). The first postmaster was Jerome T. Allen. This interior view shows the Allens waiting for some customers.

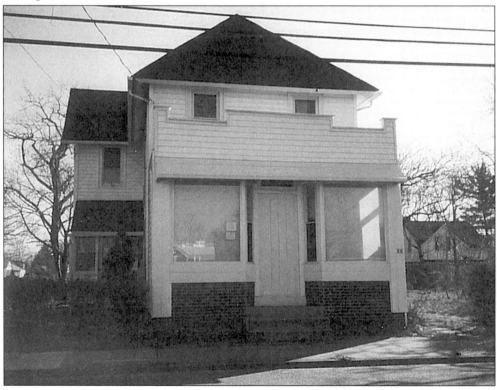

The old store is seen here as it stands today. Jerome T. Allen passed away in 1906 and his daughter Antoinette was appointed postmistress. She held that position for 32 years, retiring at age 84. She lived to be 100 years old and passed away in 1956. She was related to James P. Allaire of the Allaire Village. (Courtesy of the *History of Wall Township Post Offices*.)

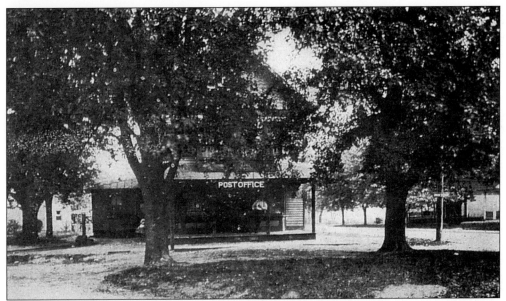

A post office was established in Sea Plain in 1873. The name was changed to Lake Como in 1887. This post office served Wall residents in the eastern section of the town, which became Spring Lake Heights in 1927. Mr. Allen D. Wickham was listed as postmaster in 1891 until Francis M. Reeves took over in 1895. Mr. Wickham again received the job in 1899 until 1919. (Courtesy of *History of Wall Township Post Offices*.)

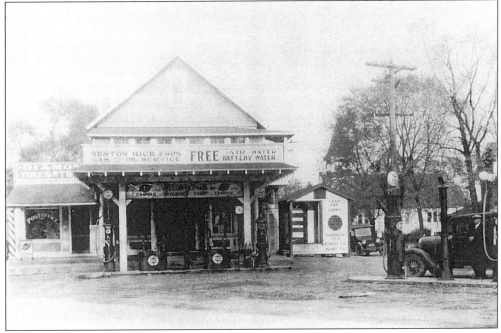

The Como Post Office was located on what is now Route 71 and Church Street. Weston Rice was the postmaster here until Mary Vanderhoef was appointed in 1934. (Courtesy of *History of Wall Township Post Offices*.)

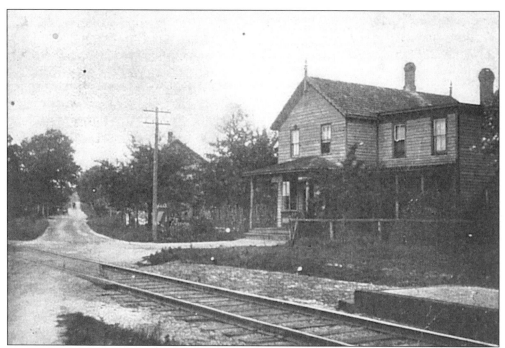

The Allenwood Post Office was established in 1874. Thomas Allen operated this store on the south side of the railroad tracks on Ramshorne Drive. He was also listed as postmaster from 1888 until 1897, when William P. La Fetra took over. (Courtesy of the *History of Wall Township Post Offices*.)

This home at 3113 Atlantic Avenue in the Allenwood section was also a post office. Grace Post lived here and was the postmistress from 1911 until 1917. (Courtesy of the Old Wall Historical Society.)

The brick building in the center of Allenwood has been used as a wheelwright and blacksmith shop. The Allenwood Post Office was also located there for many years. Today it is a real estate office. The building on the right was the home of the Allenwood Grange. The Allenwood Church can be seen on the left with just a dirt road in front of it.

This view from the old Allenwood General Store looks out the front door at the post office. Note the antiques in the store, which was operated by the Kell family.

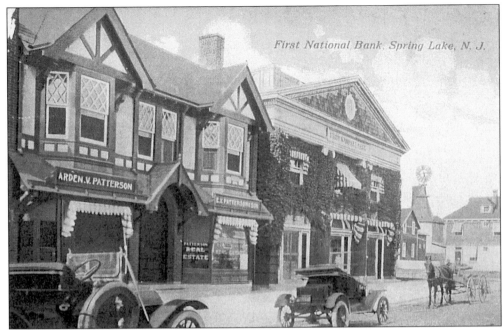

Wall residents had no banks in the township until the 1960s, when the Belmar Bank opened up a branch on Route 35 and Eighteenth Avenue. Another banks residents relied on was the Spring Lake Bank, which was established in the early 1900s.

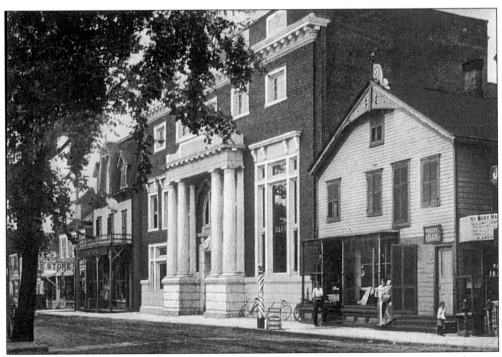

One of the other banks Wall residents used was the Manasquan Bank, which also housed a post office from 1906 till 1951. Next door was a barbershop, but many farmers skipped such expenses and had their hair cut by their wives.

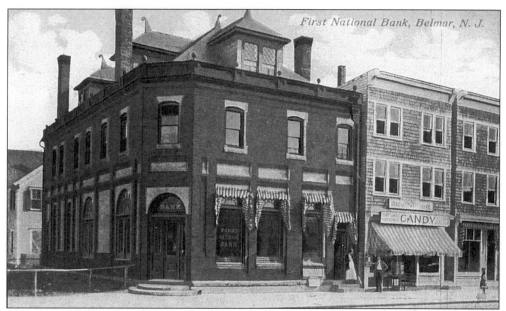

First National Bank, Belmar, N. J.

The Belmar First National Bank was located on the southeast corner of F Street and Ninth Avenue. Note the cigar store Indian in front of the candy store. (Courtesy of Bob White.)

The Belmar Bank offered many services to Wall Township residents, including a Christmas Club. (Courtesy of Bob White.)

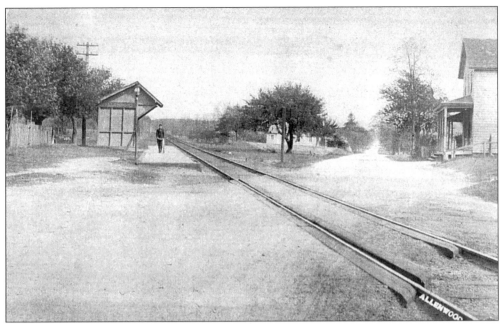

The first Allenwood Train Station was on the east side of the tracks, heading south on Ramshorne Drive. The small building was just large enough to keep the riders waiting for the train out of the wind and rain. On December 23, 1898, five Allenwood residents died in a train and wagon crash. The residents were just coming back from Christmas shopping in Asbury Park.

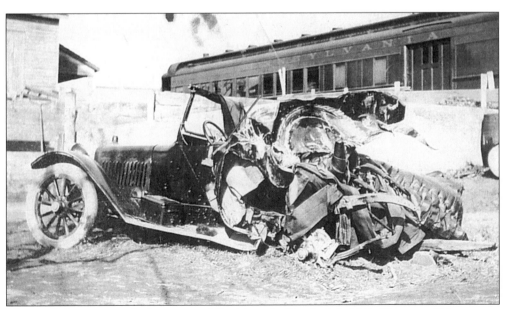

This is all that remained of an automobile driven by Dr. Archibald S. Higgens of Manasquan after it was hit at the same crossing in Allenwood on January 27, 1916. Dr. Higgens and his wife, Anna S. Higgens, were killed in the collision.

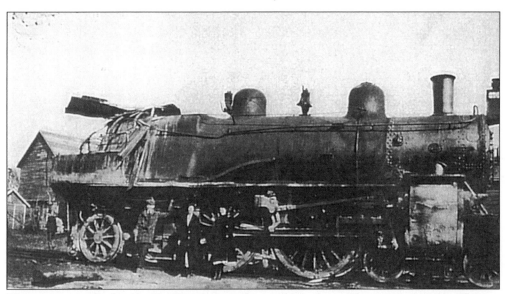

The engine involved in the Dr. Higgens' accident is shown here. The train's engineer, Thomas Berrien, also died in the crash.

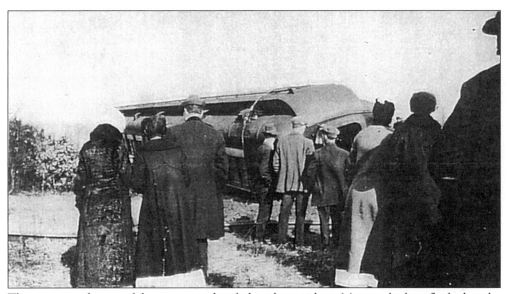

The engine and some of the cars were derailed in the accident. Many onlookers flocked to the scene, where they learned of the notable doctor's death.

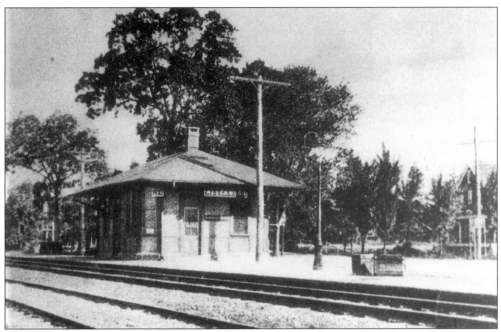

The last railroad station in Allenwood was torn down in the 1950s. The Allenwood Station was in the southwestern part of the township; on the opposite, or northwestern, part of the township was the Shark River Station, in the Collingwood Park area.

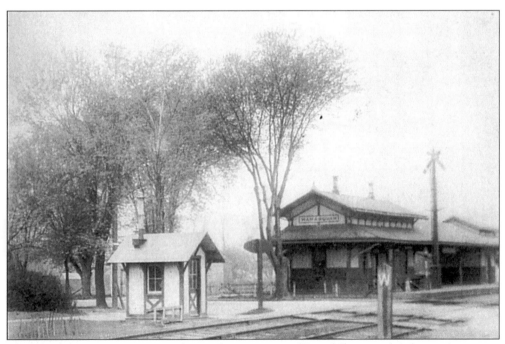

The Broad Street station was on the southwest corner of Broad Street and Atlantic Avenue in Manasquan. The tiny shanty on the left kept the railroad crossing guard warm in the winter with a little pot-bellied stove. Automatic gates replaced the crossing guards in the 1950s.

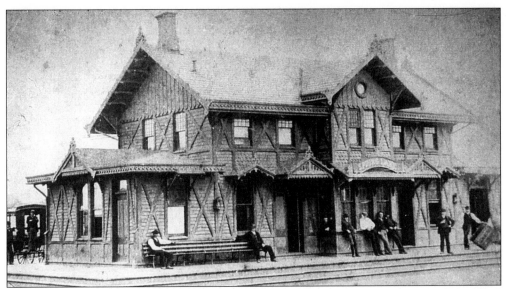

This railroad station was built in Spring Lake in 1877, while Spring Lake was still part of Wall Township (the two separated in 1892). In 1880, the building was moved down the tracks to Manasquan.

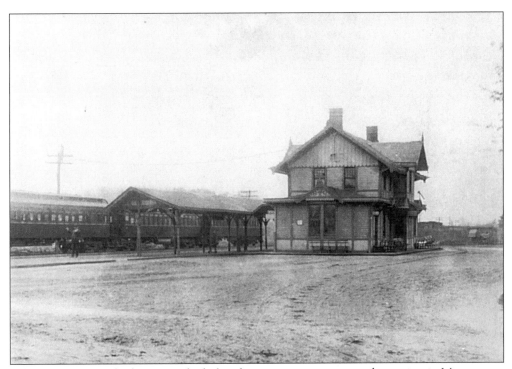

A large canopy was built to provide shelter for waiting passengers at the station in Manasquan. Part of the railroad station became the Manasquan Historical Society as well as a taxi service. The building burned down in the 1990s.

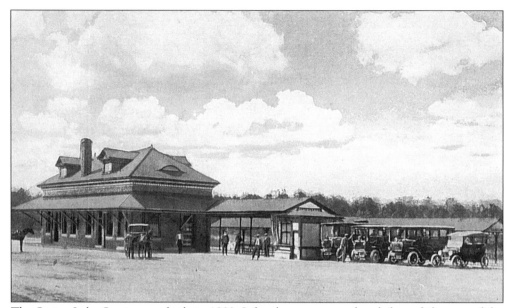

The Spring Lake Station was built in 1880. It has been renovated and, for awhile, part of the building was used as a branch of a bank. Note the old taxicabs waiting for the train to take residents to their homes and hotels.

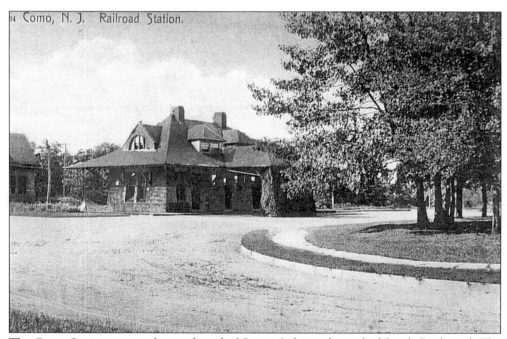

The Como Station was in the north end of Spring Lake at the end of South Boulevard. The station was built in 1887 and used until it was torn down around 1933.

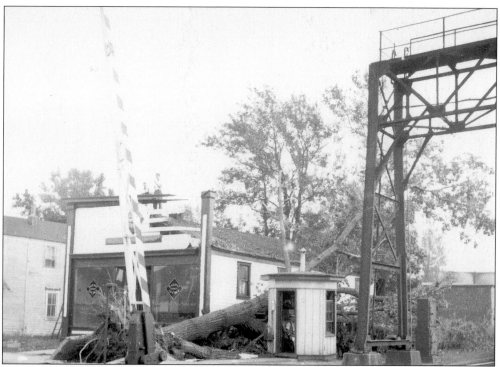

The Tenth Avenue railroad crossing in Belmar was this scene of a falling tree, which just missed the shanty and the railroad crossing guard. (Courtesy of Bob White.)

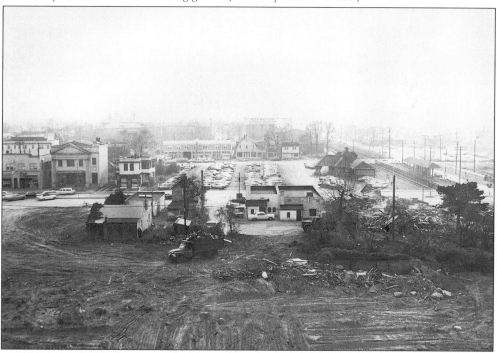

The Belmar Railroad Station was in Wall Township until 1893. This picture was taken during urban renewal in the 1960s. (Courtesy of Bob White.)

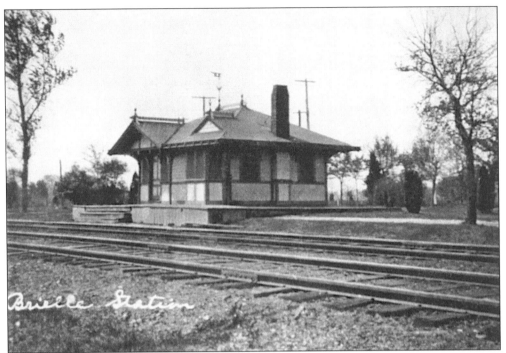

The Brielle Railroad Station, which was in Wall until 1919, served the southern part of the township. The building no longer stands; a marker indicates the spot where it once stood on Brielle Avenue.

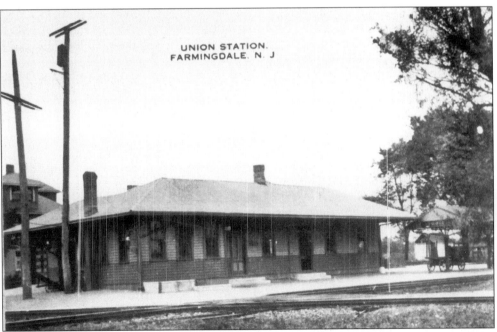

Although Farmingdale was not a part of Wall Township, the railroad station served the residents of the western end.

Five

POLICE, FIRES, AND STREET VIEWS

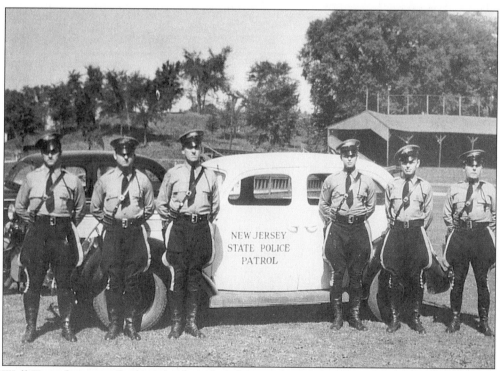

Wall Township never had much of a police department for the 32 square miles it had. Vernon Shibla was appointed police chief in 1931 and never had much help. The New Jersey State Police patrolled Wall, covering traffic accidents and major crimes. They worked from a barracks on Route 33 in Howell Township.

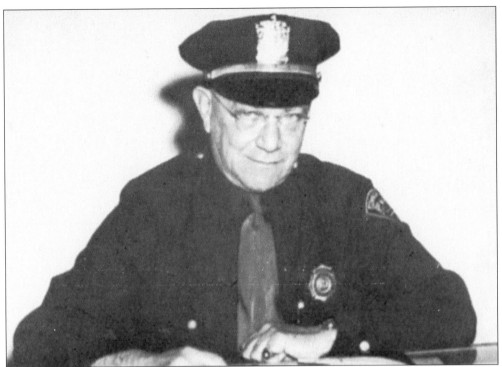

Vernon Shibla (1894–1960) was born in Freehold and settled in West Belmar. On February 25, 1931, Mr. Shibla became the first chief of police of Wall Township. He worked practically alone and was subject to call 24 hours a day, for which he received a fee of $200 a year. He continued working alone for 20 years before another patrolman, John Downs, was appointed in 1952. From then on, the department kept growing.

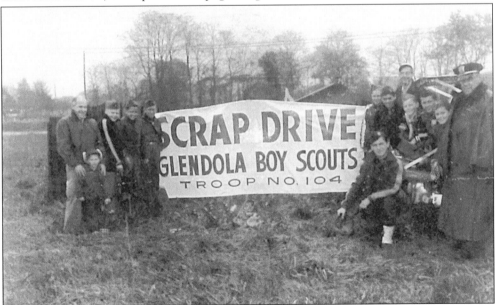

In World War II, Police Chief Vernon Shibla spearheaded a scrap drive. He is pictured here on the right side of the picture. The taller man to his right was Troop #104 Scoutmaster Bob Todd.

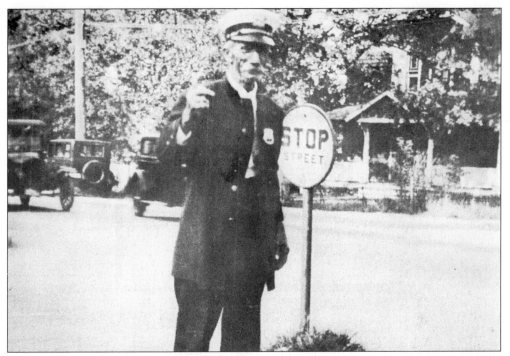

Stephen Tuzeneu was born in Tinton Falls in 1863. He was appointed the first special policeman under Vernon Shibla in 1931 and patrolled in his own auto. He was appointed as the first probation officer for the West Belmar Grammar School and also served as a crossing guard. He served in these positions until his death in 1934.

This collection of badges and patches was worn by various Wall police officers.

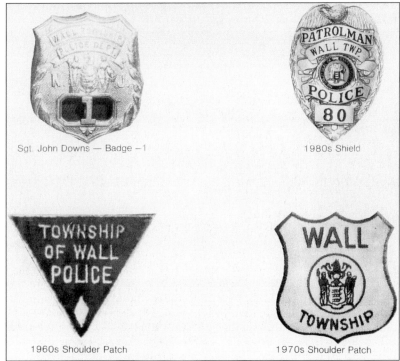

Sgt. John Downs — Badge —1

1980s Shield

1960s Shoulder Patch

1970s Shoulder Patch

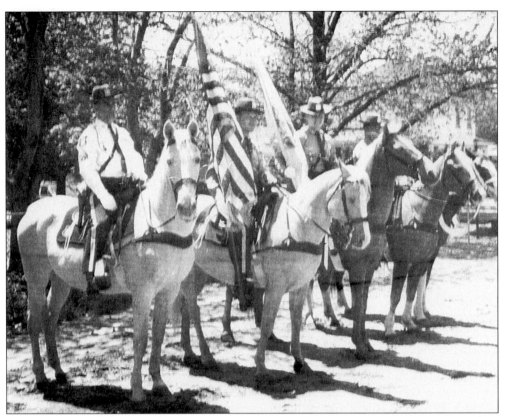

This *c.* 1960s Wall Police Color Guard consisted of, from left to right, John Downs, Robert Brice, and Leo Kubaitis.

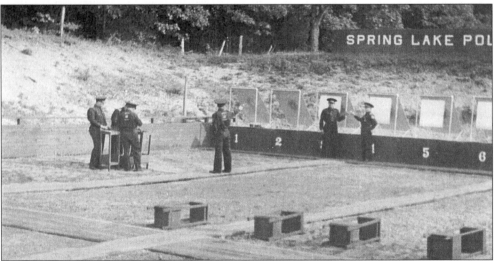

The Spring Lake Police Pistol Range was on the south side of Allaire Road, and east of the Wall Township Police Department. The late Spring Lake Police Chief Russell Hurden Sr. founded the range in 1931. Police departments from the tri-state area would meet at the range for pistol matches every year. Girlfriends and wives watched the shooters from the picnic tables on the hill on the left in the picture.

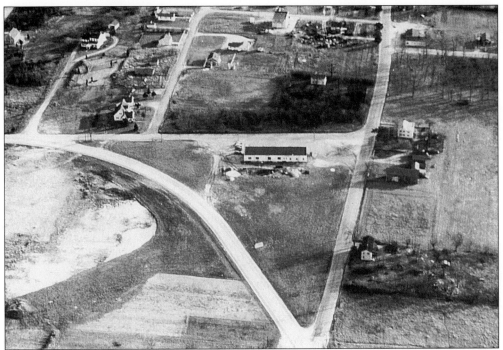

The old municipal building, the second home of the police department, is located between New Bedford Road and Belmar Boulevard, in the center of this 1950s photograph. The police department was housed there until 1960, when it moved to 2034 Route 35, the current location of the Wicker Place. It was originally housed in an old school building (see p. 56). In August 1960, Walter Witt was appointed Wall police chief, an indication of how much the department had grown. To the right of the picture is Barkalow Farm, now the Old Wall Historical Society.

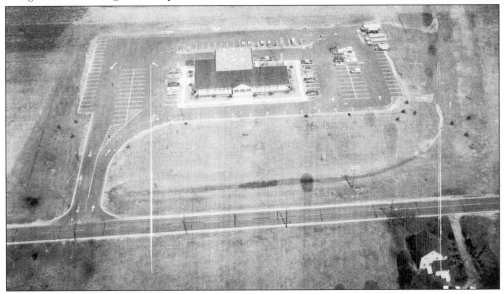

Since this 1975 view of the new Wall Township Police Department was taken, a library and a municipal building have been built on the northeast corner of Bailey's Corner Road and Allaire Road.

Wall Township's first jail is located on Fifth Avenue, behind the Spring Lake Fire Co. #1, in Spring Lake. It was built before 1892.

These cells are still in the building that was once the Wall Police Department at 2034 Route 35. This building is now Wicker Plus. Baskets hang from the old cell doors. (Courtesy of the Carmine Basile Family.)

The first Glendola Fire Company alarm was this iron locomotive wheel rim, which hung from a cross bar. It was sounded by someone hammering it. It hung in Harry Hurley's current yard at Belmar Boulevard and Allenwood Road. In 1930, the bell was donated to the Shark River Hills Fire Department and was placed at their first building outside of Barney Wright's store on North Riverside Drive. (Courtesy of Jack Herbert, former fire chief of the Shark River Hills Fire Department.)

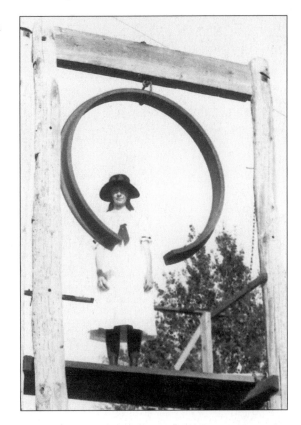

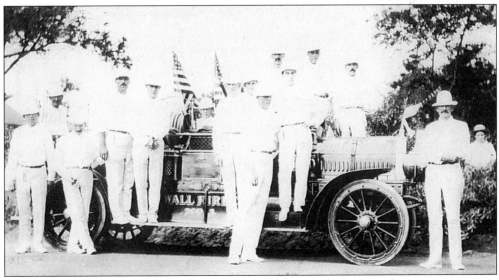

The West Belmar Fire Company #1 shown here is getting ready for a parade, c. 1920s.

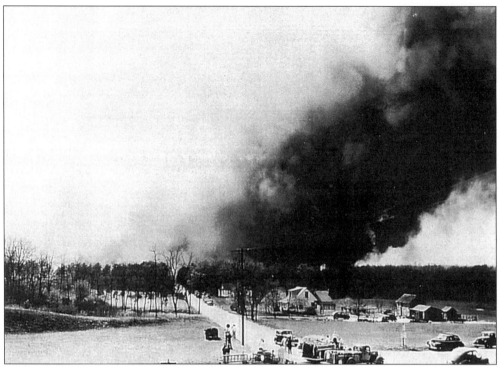

In the 1940s, there was a large forest fire in Howell Township. The Glendola Fire Company waits here for orders on Route 34 and Hurley Pond Road. Wall Stadium would be on the left side of the picture today. (Courtesy of Edith Derres.)

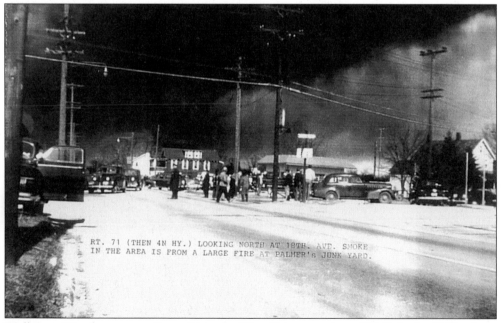

RT. 71 (THEN 4N HY.) LOOKING NORTH AT 18TH. AVE. SMOKE IN THE AREA IS FROM A LARGE FIRE AT PALMER's JUNK YARD.

Wall Auto Wreckers was on Route 71 in the West Belmar section of Wall. In the 1950s, there was a fire there and this picture shows the traffic being re-routed at Eighteenth Avenue. The sky was darkened by thick smoke.

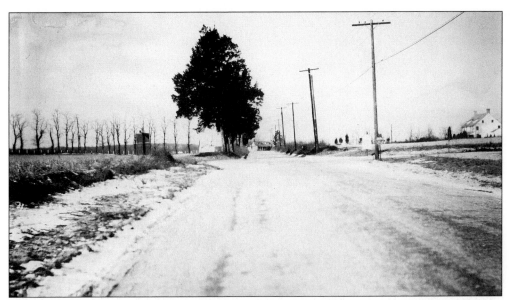

This 1940s view of Sea Girt Avenue was taken looking west across Route 35. Where did all the traffic go? Seen on the right is the Old Tilton-Morris Home (see p. 72). The Sea Girt Mall would be on the left today.

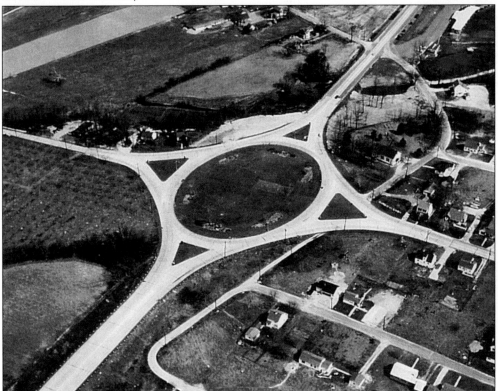

This early view of the Manasquan Circle shows where Route 35 and Atlantic Avenue meet. Peddler's Village would be on the left. In the 1950s, there was a golf driving range located about where the Sea Girt Mall is today. (Courtesy of the Harry Hurley Family.)

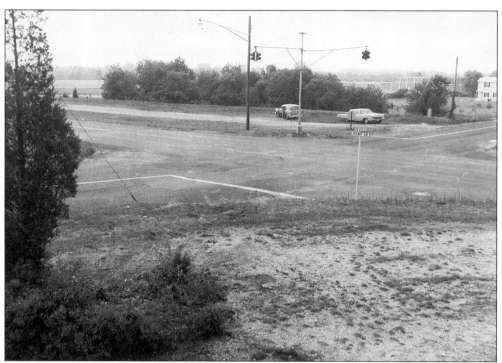

In 1963, Route 138 and New Bedford Road just had a blinker light to control the traffic. The new Wall High School is visible at the top of the picture.

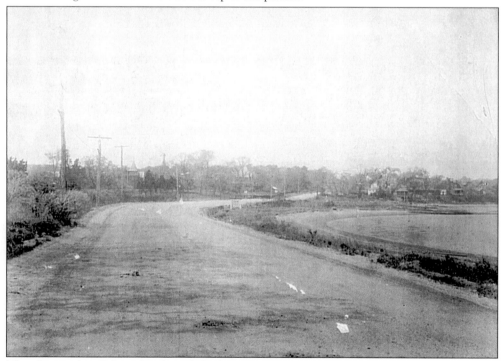

This dirt road is Belmar Boulevard, looking west from Route 35. At the time of this 1910 picture it was called River Road. The office of Dr. Byung Choi would be on the left today.

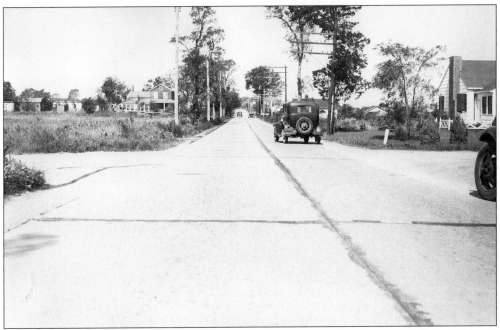

In this 1941 view of Belmar Boulevard, the photographer was looking west from Monmouth Boulevard, which was just a dirt road at the time.

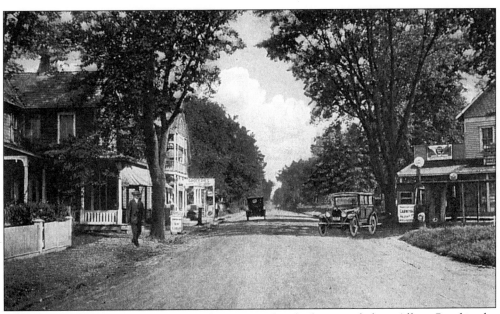

This photograph of Route 71 or 4N Highway was taken looking north from Allaire Road in the Como section of the township.

The Allenwood-Lakewood Road Bridge was used as a passageway to the Toms River area as early as the American Revolution. It was a narrow bridge with room for just one wagon. In 1985, the bridge was replaced with a new one. It opened again in 1992.

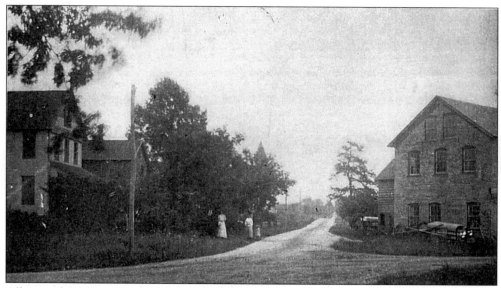

Allenwood Center is shown here c. 1900. The blacksmith shop/post office building is on the right; the dirt lane heads east toward the Allenwood Church.

Six

ALLAIRE,
ENTERTAINMENT,
AND MISCELLANEOUS

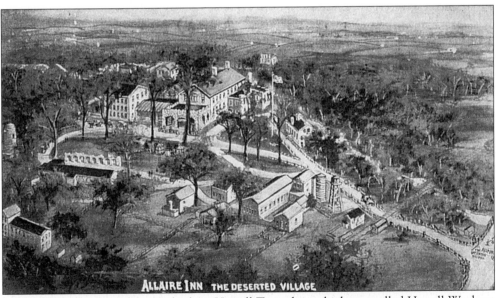

ALLAIRE INN THE DESERTED VILLAGE

In the 1700s, an iron works was built in Howell Township, which was called Howell Works at one time. In 1851, the area became Wall Township. In the early 1800s, James P. Allaire began to put together a village that prospered for many years. After his death, the village began to decay until it became deserted. In this bird's-eye view of Allaire, one can see that some of the buildings pictured are now gone. If the Allaire group had not restored the village, the buildings would all be gone today.

The old road leading into Allaire Village is still there but a newer main entrance is further west. Part of this dirt road is used as an exit for visitors.

These barns were on the left as you entered the village site, but most are gone now. In the 1940s and '50s, a family lived in the stone building on the right.

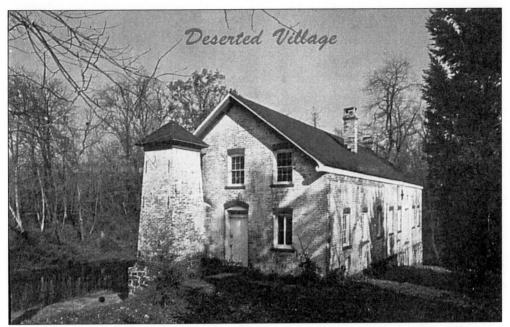

Opposite the old barns on the right side of the entrance was the first building in Allaire, an enameling furnace. This building was used for glazing the interior of pots and pans. It was also renovated and used as a dwelling in the 1940s and '50s.

In 1819, a steamboat crossed the Atlantic Ocean in 29 days. The 40-inch cylinder for the *Savannah* apparently was cast at the Allaire Works. In 1820, when the *Savannah* was sold at auction, Mr. Allaire purchased the engine for $1,600. His son Hal recalled that, as a boy, he had seen the engine on display at the works adorned with a metal plate saying it had been made there. (Courtesy of *Allaires Lost Empire*.)

113

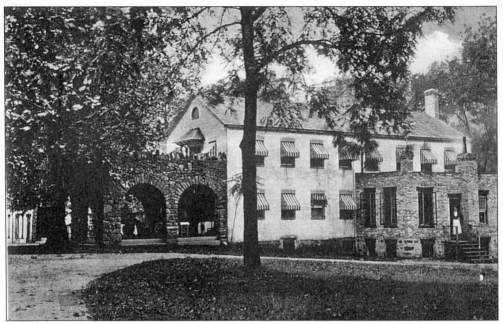

This building was formerly a carpentry and wheelwright shop. In 1928, William DeLisle used the building as a restaurant. Travelers from the shore would often stop in to relax and dine.

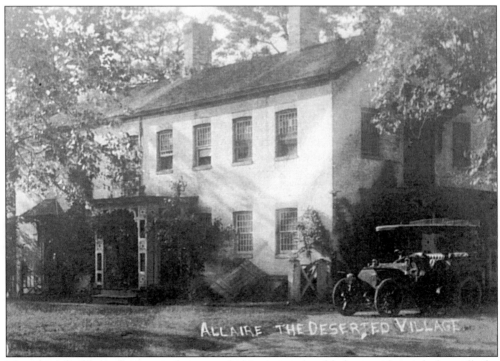

The same building shown at the top of this page resembled a residence before all the renovations were made.

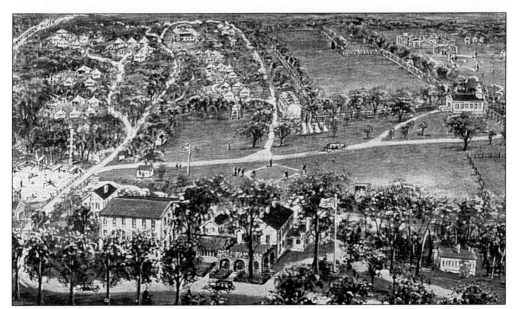

This bird's-eye view of the village was taken when the Boy Scouts had it leased. In 1928, the Monmouth and Ocean Council of Boy Scouts obtained a 20-year lease for 200 acres at $1 per year. Note the baseball field in the center of the picture.

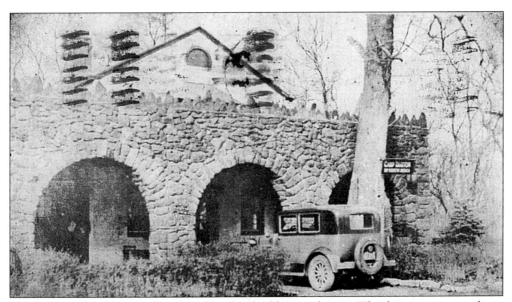

Headquarters for the council was in the same building as the inn. The front room mantel was marked Camp Burton 1929. (Courtesy of *Allaires Lost Empire*.)

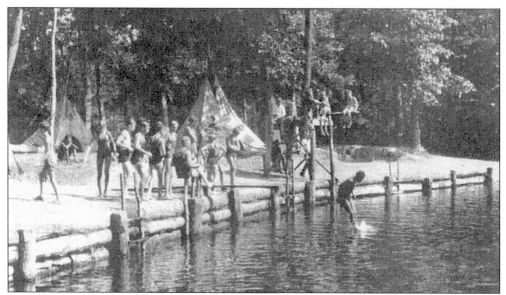

Back in the scouting days of Allaire, the waters of the streams and lakes were so clear you could see the bottom.

Although there were dwellings at Allaire Village where the Boy Scouts could sleep, they still pitched tents and roughed it. They put the tents in a large circle and had a fire in the middle.

CAMP BURTON-AT-ALLAIRE, BOY SCOUTS OF AMERICA
CONDUCTED BY MONMOUTH COUNCIL, FARMINGDALE, N. J.

MERIT BADGE CERTIFICATE

This is to Certify that:-

Scout *John Merkwhill* Rank *2nd* Class

Troop *5* Council *Monmouth*

while in attendance at this camp completed the requirements for the

Leathercraft Merit Badge

in accordance with the standards prescribed by the National Council.

Dated *Aug. 27, /32.* Signed *M.E. Halbrook*
Authorized Examiner

Approved *F. Abegg*
Scoutcraft Director

This certificate is subject to action of the local Court of Honor having jurisdiction over the above named scout

This is a copy of a merit badge in leather craft that was given to a Boy Scout at Camp Burton in 1932.

BOY SCOUT RESERVATION
ALLAIRE, N. J.

P. O. BOX 172. FARMINGDALE, N. J.

FARMINGDALE
JUN 4
7 –PM
1931
N. J.

Mr. L. L. McDonald
2 Park Avenue
New York City, N. Y.

Another momento from the Boy Scout era at Allaire is seen here. Although the Monmouth and Ocean Council had a 20-year lease, the U.S. Army took over the area during World War II and practiced maneuvers there. The Boy Scouts were then moved to West Hurley Pond Road in Howell. This was called Camp Housman.

MEMBERS WITH CARS TO DATE FOR RACING ONLY			
Name	Car Make	Year	No.
B. Kisner & B. Martin	Chev.	1929	13
Bill Ireland	Ford	1935	14
Herb. Allison	Ford	1932	11
Dick Davis	Ford	1933	40
Bob Cook	Ford	1937	77
Dick Megill	Ford	1935	31
Oscar Morton	Ford	1937	5
Ted Schneider	Ford	1933	77
Lou Mazurette	Ford	1931	33
Guker Bros.	Pontiac	1935	87
Duke Heller	Mercury	1939	98
George Mueller	Ford	1934	4
Joe Locklin	Ford	1938	21
Dougal Kell	Ford	1931	88

— OTHER MEMBERS —

Robert Bartlett	Dick Napoliton
Lou DeAngelis	Ray Borden
Glen Clayton	Bob Nelson
Ken Elmer	Bill Krott
Roland Gant	Pete Maclearie
Bob Jorgensen	Ken McKeon
Ken Johnson	Bill Quackenbush
James Lawhon	James Huber
Pete Lavance	Chester O. Farry
Mel Lawrence	Kenneth Farry
Don Miller	Ogdon Horton
Bob Picht	Stan Jones
Ray Wooley	John Chapman
Herb. Davis	Paul Shaughnessy
Bob Eustace	George Farrell
John Koleda	James Brown
Red Wilson	Joe Love
Lenny Blomgren	

Wall had little to offer as far as recreation or family fun goes. In 1949, a group of young men built a dirt automobile racetrack on Route 38 (then called the Army Mile). The track, known as the Shore Race Club track, was on the south side of the highway at the spot where the parkway is today. Many Wall residents turned out each Sunday to watch the races. The drivers, who competed only for trophies, would pass their leather helmets around the crowd for donations to help repair the track.

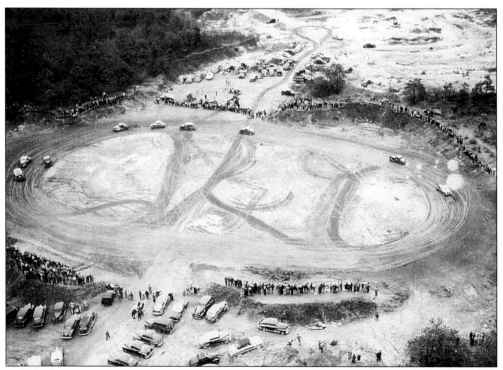

This is an aerial view of the Shore Race Club track on Route 38 in Wall Township. Some of the racers drove their racecars to the track, and had a tough time getting them home if they got into a bad wreck. They only wore a single seat belt for safety. During the races cars would occasionally flip over, get righted-up, and continue on.

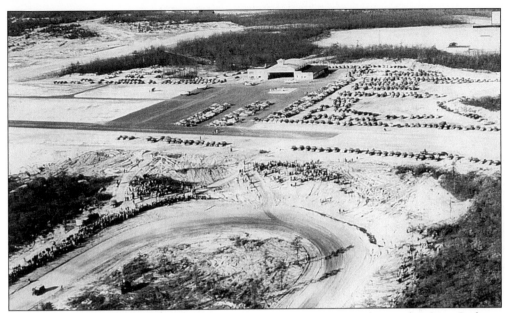

In 1950, the Shore Race Club had to leave the track on Route 38. The Garden State Parkway had begun work and went right through it. With permission from the owner of the Monmouth County Airport, Mr. Ed. Brown, the youngsters built another track on that site.

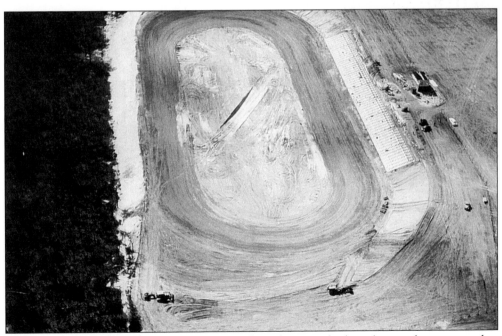

The second track did not last long either. Wall Stadium was built and many drivers started to race there professionally. This is a picture of Wall Stadium being constructed. In the center of the track was an over-and-under bridge used for a short time for motorcycle racing.

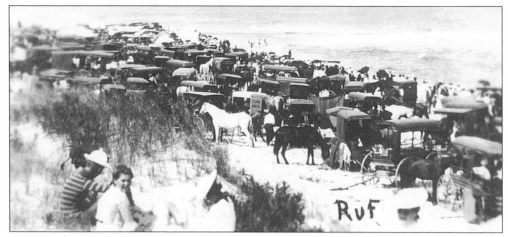

An annual event for farmers was the Big Salt-Water Day in August. This custom originated back when New Jersey was a colony. Sea Girt Beach was a favorite of the farmers. A trip from Mt. Holly, which is about 50 miles away, would take all day for the wagons to reach the site. (Courtesy of Bob White.)

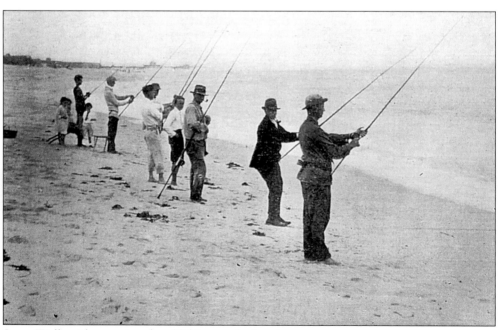

Some Wall residents enjoyed surf fishing on the beach.

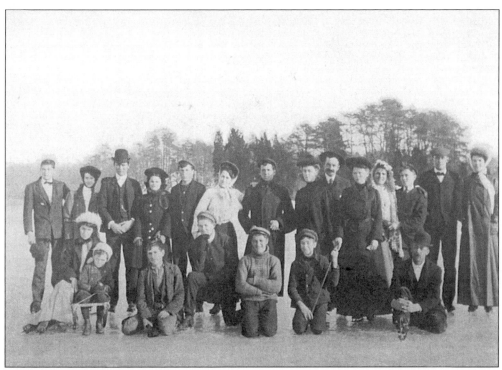

These jolly skaters of Allenwood participate in an early form of recreation. Just a short distance south on Ramshorne Drive and on the right there is an area owned by Green Acres. Now paved, there was a dirt road to the Manasquan River. A portion of the river has an area that was like a cove and Allenwood residents used it for recreation in the old days. They called it "Dead River." The child in the sleigh was Earl Woolley with his mother, Florence. His father, Albert, is the one with the Derby sitting on the right. (Courtesy of the Parks Tatum Family.)

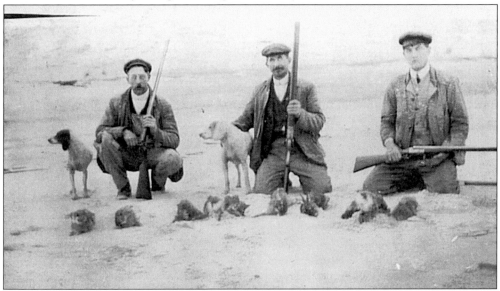

Three Allenwood residents, Albert Woolley (left), Harvey Herbert (center), and Arch Newman, show the results of a day's hunt. (Courtesy of the Parks Tatum Family.)

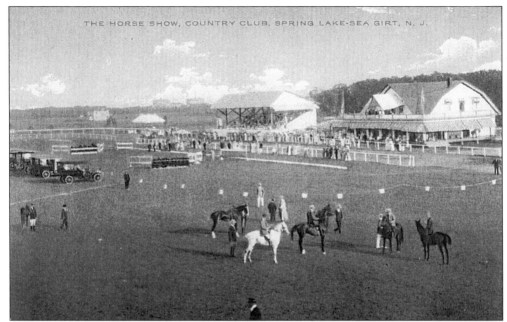

How about going to a horse show? This event was held in the 1920s at this country club located on Route 71 in Sea Girt. The building today is Squan Furniture.

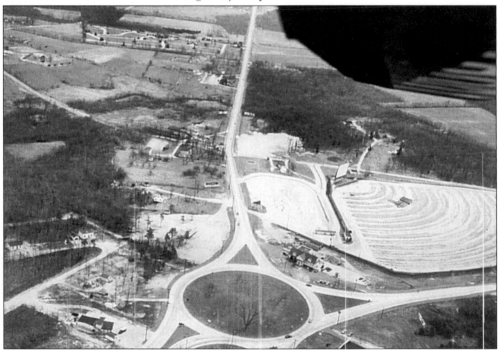

By the 1950s, Wall had really started to come up in the world. It had three drive-in theaters—the Brielle Drive-In at the Brielle Circle, the Fly In Drive In at the Monmouth County Airport on Route 34, and the Shore Drive-In (pictured here) at the Collingwood Circle. This picture of the circle was taken looking east; the Monmouth Memorial Cemetery can be seen in the distance on Route 33. (Courtesy of the Harry Hurley Family.)

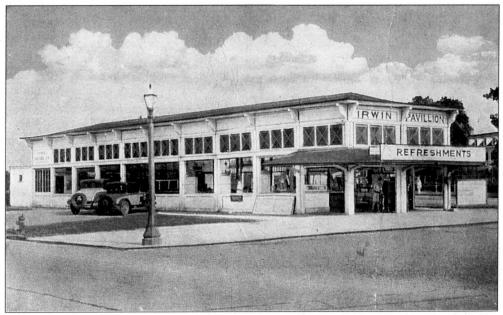

Seen here is some of Wall Township's earliest fast food. This hot dog stand was in Sea Girt near the entrance to the National Guard Camp. The restaurant was also called Krug's.

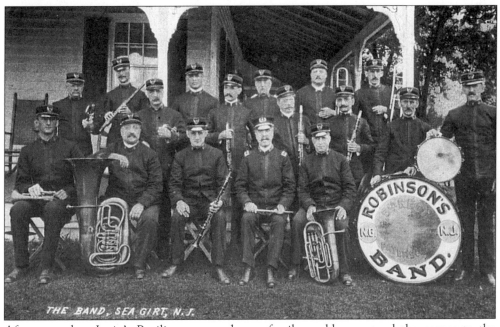

After a meal at Irwin's Pavilion, you and your family could go around the corner to the campgrounds and listen to a band concert.

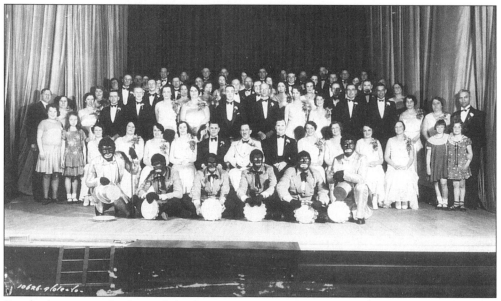

People also went to the Spring Lake Community House for entertainment. They always seemed to have something going on. The man in the center of the second row with the tuxedo on was the master of ceremony: Lew Norris.

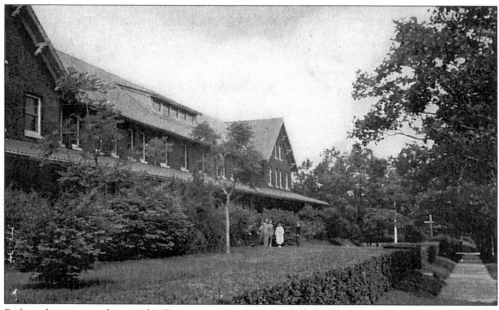

Before the army took over the Evans area in 1941, Gaglielmo Marconi sold the property to the local branch of the KKK. The Klan used it as their base from the 1920s until 1937, when it was sold to an evangelist from Philadelphia. He called it Kings College. The 218 acres are to be turned over to Wall Township in 1999.

In the early years, when someone was sick or injured, there was no first aid squad and very few doctors to contact, so families had to rely on each other to heal. The Ann May Hospital was one of the first in the area. Mrs. Albionia Whartenby donated land and money to construct a hospital at First and Vroom Avenues in Spring Lake. The dedication was in June 1904, and the building was named after her daughter. In 1931, the Fitkin Hospital in Neptune was built. It is now Jersey Shore Medical Center. The Ann May was eventually torn down.

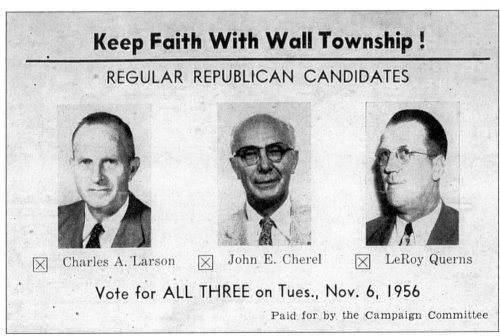

This postcard was sent to the voters of Wall Township in 1956.

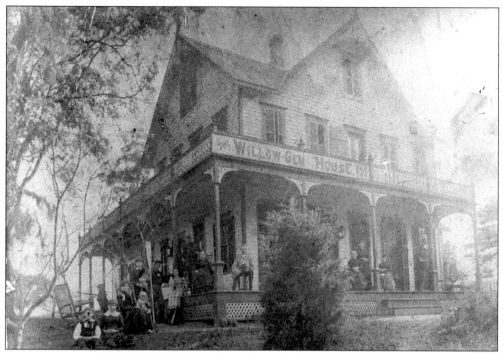

According to the 1873 Wall Township Map, the King family owned this old home. It was later purchased by the Finley family, who turned it into a hotel called Willow Gem.

In the 1950s, the building was torn down and this motel was built on its site at Route 35 and Belmar Boulevard. The motel was the Lil-Mar, later called Charline. Today, there is a Shell station on the property.

B. Frank and Catherine R. Hurley pose for a photograph with their home in the background. It was located on the old road to Manasquan (now Route 71) and Church Street in Lake Como, which was part of Wall Township and is now Spring Lake Heights. (Courtesy of Dick Hurley.)

This 1910 photograph shows a peaceful scene of summer homes along Shark River.

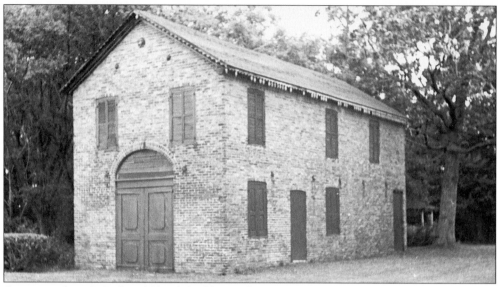

Constructed *c.* 1840, this old brick building still stands at 1740 New Bedford Road right across the street from the Old Wall Historical Society. It was built by Jackson Morris and used as a blacksmith and wheelwright shop.

Mildred Hurley Cottrell is seen here with the old Lake Como Church in the background. Many older Wall residents attended this church on Church Street just off Route 71. (Courtesy of Dick Hurley.)